visual aid²

you can never know enough stuff

Draught Associates

D0176951

Famous heights

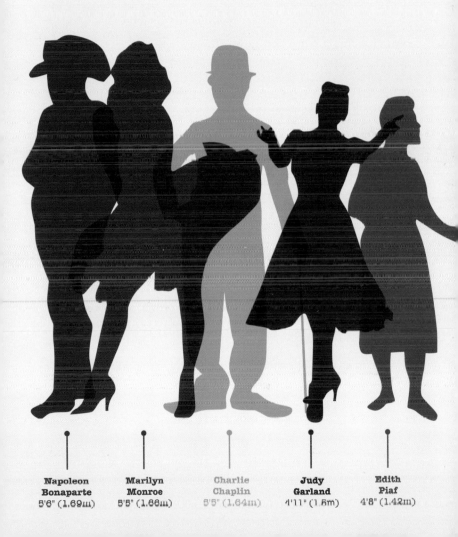

Napoleon
Bonaparte
5'6" (1.69m)

Marilyn
Monroe
5'5" (1.66m)

Charlie
Chaplin
5'5" (1.64m)

Judy
Garland
4'11" (1.5m)

Edith
Piaf
4'8" (1.42m)

Sports trophies

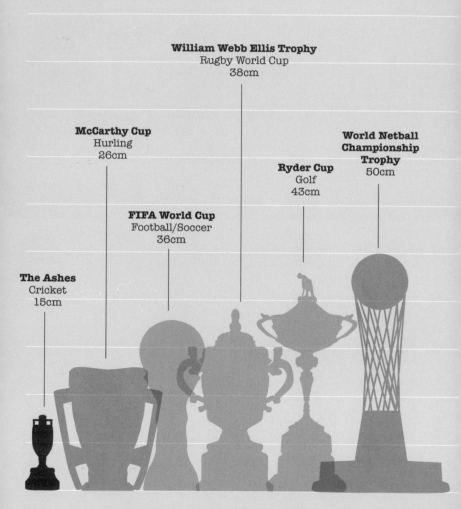

William Webb Ellis Trophy
Rugby World Cup
38cm

McCarthy Cup
Hurling
26cm

**World Netball
Championship
Trophy**
50cm

Ryder Cup
Golf
43cm

FIFA World Cup
Football/Soccer
36cm

The Ashes
Cricket
15cm

Davis Cup
Tennis
110cm

Stanley Cup
Ice Hockey (NHL)
89.5cm

America's Cup
Sailing
68.5cm

**Vince Lombardi
Trophy**
Super Bowl
American Football
56cm

Showbiz awards

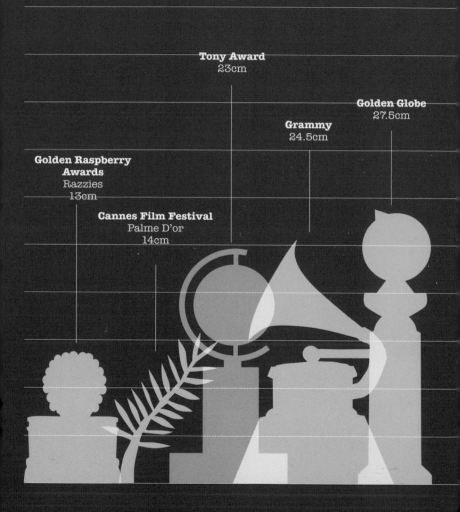

Tony Award
23cm

Golden Globe
27.5cm

Grammy
24.5cm

Golden Raspberry Awards
Razzies
13cm

Cannes Film Festival
Palme D'or
14cm

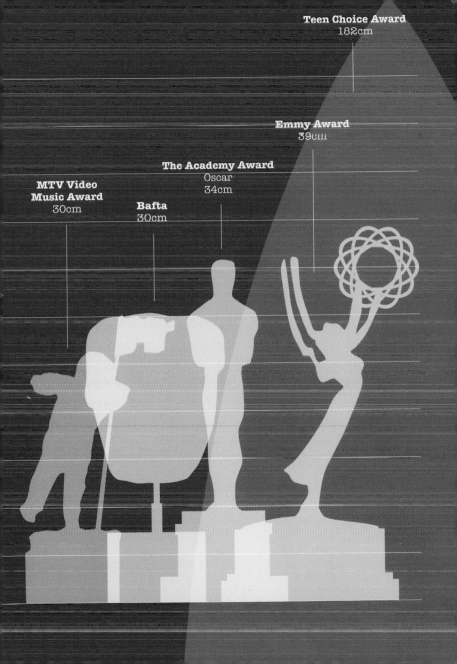

Teen Choice Award
182cm

Emmy Award
39cm

The Academy Award
Oscar
34cm

MTV Video
Music Award
30cm

Bafta
30cm

Baseball umpire signals

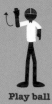

Play ball

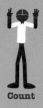

Count

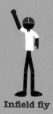

Strike/Out

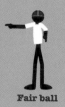

Fair ball

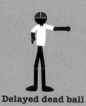

Delayed dead ball

Infield fly

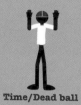

Time/Dead ball

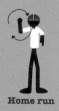

Home run

Double

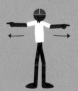

Trapped ball/Safe

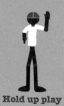

Hold up play

Foul tip

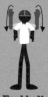

Foul ball

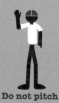

Do not pitch

Time play

Cricket umpire signals

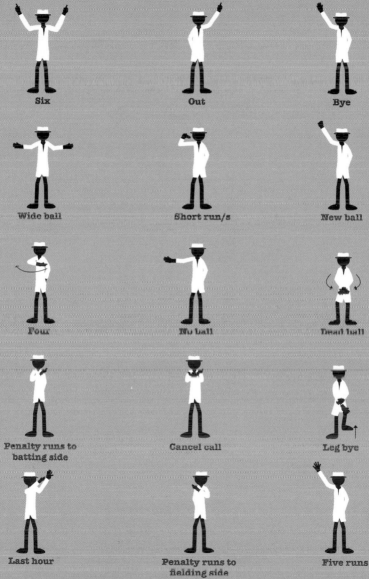

Ballet positions

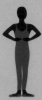 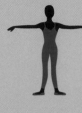 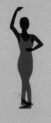 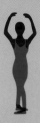

1st **2nd** **3rd** **4th** **5th**

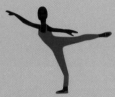 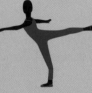

1st Arabesque **2nd Arabesque** **3rd Arabesque**

 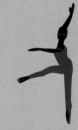 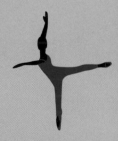

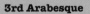

1st Plies **2nd Plies** **Attitude devant** **Attitude derrière**

Gymnastics positions

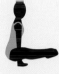

L support

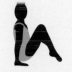

Tuck support

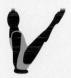

V-sit support

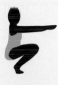

Squat

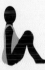

Tuck

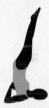

Candle

Knee stand

Straddle

Knee lunge

Half split

Y Scale

Side arm cross

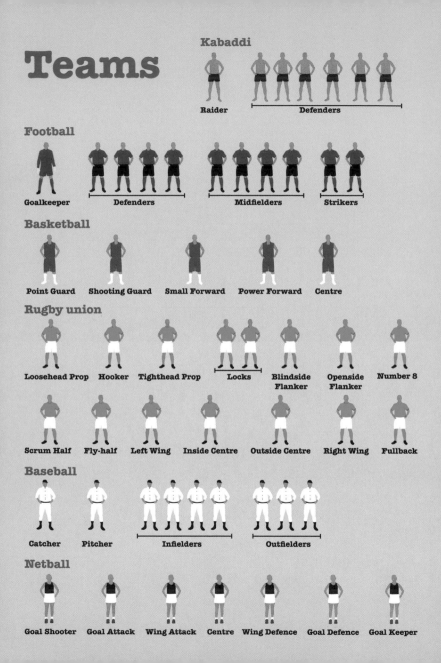

Teams

Kabaddi

Raider **Defenders**

Football

Goalkeeper **Defenders** **Midfielders** **Strikers**

Basketball

Point Guard **Shooting Guard** **Small Forward** **Power Forward** **Centre**

Rugby union

Loosehead Prop **Hooker** **Tighthead Prop** **Locks** **Blindside Flanker** **Openside Flanker** **Number 8**

Scrum Half **Fly-half** **Left Wing** **Inside Centre** **Outside Centre** **Right Wing** **Fullback**

Baseball

Catcher **Pitcher** **Infielders** **Outfielders**

Netball

Goal Shooter **Goal Attack** **Wing Attack** **Centre** **Wing Defence** **Goal Defence** **Goal Keeper**

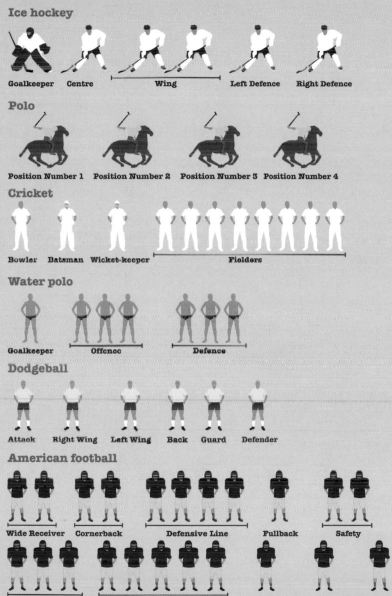

Ice hockey

Goalkeeper Centre Wing Left Defence Right Defence

Polo

Position Number 1 Position Number 2 Position Number 3 Position Number 4

Cricket

Bowler Batsman Wicket-keeper Fielders

Water polo

Goalkeeper Offence Defence

Dodgeball

Attack Right Wing Left Wing Back Guard Defender

American football

Wide Receiver Cornerback Defensive Line Fullback Safety

Linebacker Offensive Line Quarterback Running Back Tight End

If at the point when a team mate passes the ball to you, and you are in the following position:

1. In your opponents' half
2. Nearer to your opponents' goal line than the ball
3. Fewer than two opponents are ahead of you

you are deemed to be offside

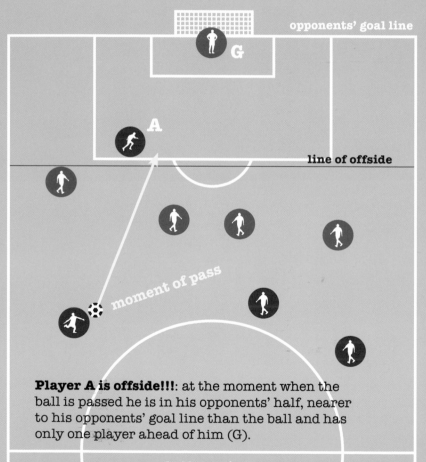

opponents' goal line

G

A

line of offside

moment of pass

Player A is offside!!!: at the moment when the ball is passed he is in his opponents' half, nearer to his opponents' goal line than the ball and has only one player ahead of him (G).

halfway line

Offside!!!

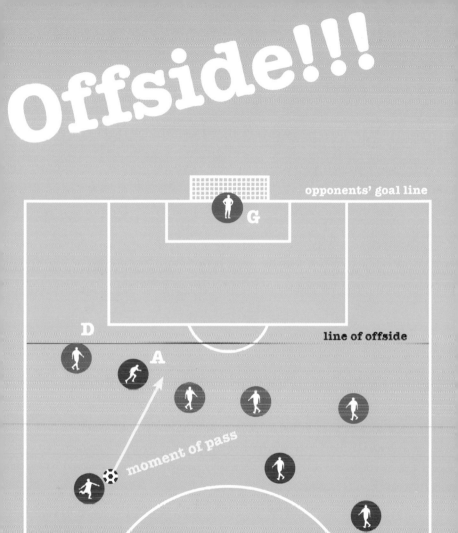

opponents' goal line

G

line of offside

D

A

moment of pass

Player A is NOT offside!!!: the moment when the ball is passed he is in his opponents' half, nearer to his opponents' goal line than the ball, BUT has two players ahead of him (G & D).

halfway line

Bats, sticks and racquets

Badminton
India 1860s

Ping Pong
England 1880s

Lacrosse
North America
12th century

Tennis
England 1859

Squash
France 1500s

Cricket
England 16th century

Baseball
USA 1845

Racquetball
USA 1950

Polo
Persia 600BC

Field hockey
UK 1849

Jai alai
Spain early
18th century

Hurling
Ireland 1879

Xare
Spain early 19th century

Ice hockey
Canada 1875

Cycles

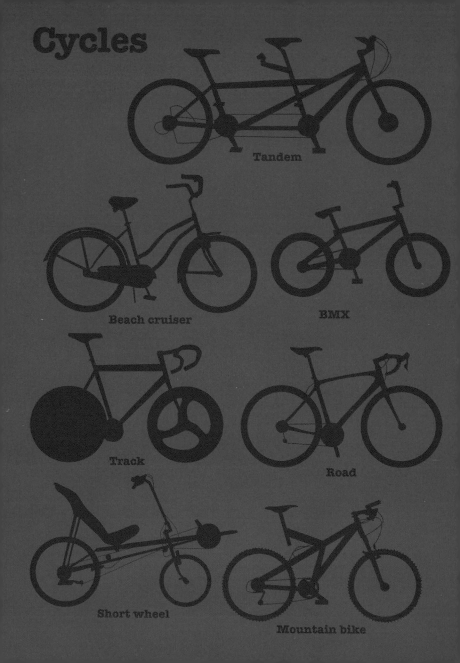

Tandem

Beach cruiser

BMX

Track

Road

Short wheel

Mountain bike

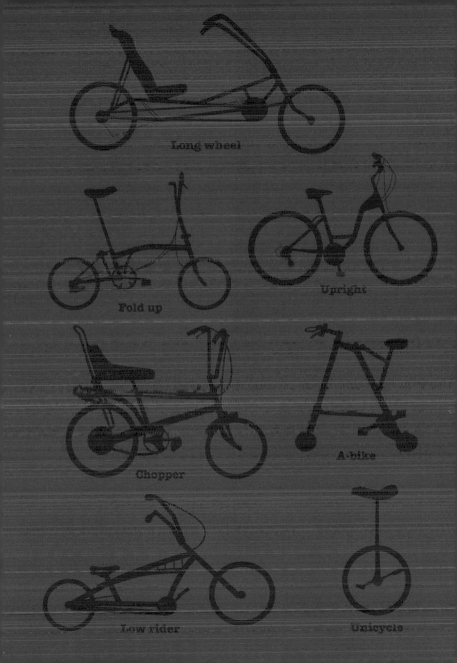

Long wheel

Fold up

Upright

Chopper

A-bike

Low rider

Unicycle

Skateboarding

Ollie

1.

2.

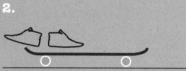

3.

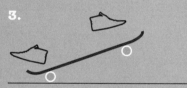

4.

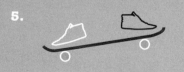

5.

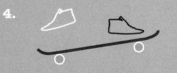

6.

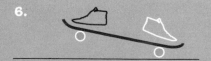

Kick flip

1.

2.

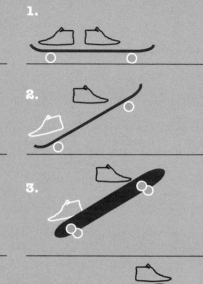

3.

4.

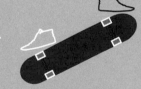

5.

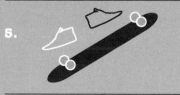

6.

Surfing

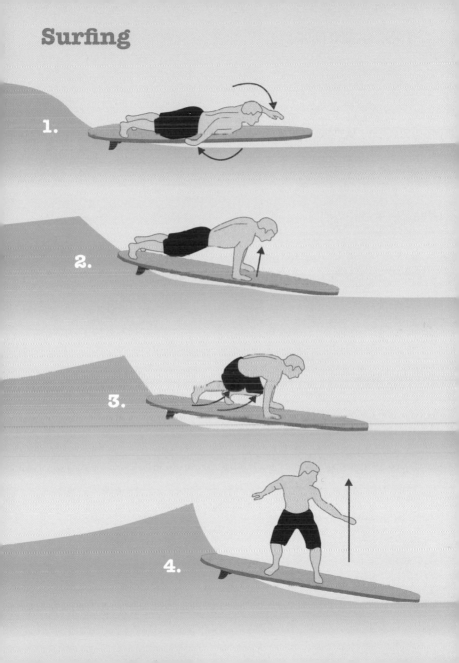

Wave breaks

Spilling/rolling
breaker

gently sloping shoreline

Plunging/dumping
breaker

moderately sloping shoreline

Surging
breaker

steeply sloping shoreline

Tides

Moon

Moon's gravity pulls water away from the Earth's surface

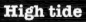

High tide

Earth

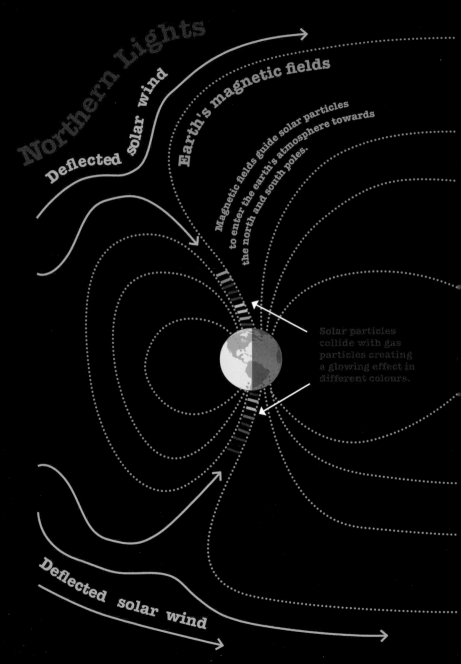

Northern Lights

Deflected solar wind

Earth's magnetic fields

Magnetic fields guide solar particles to enter the earth's atmosphere towards the north and south poles.

Solar particles collide with gas particles creating a glowing effect in different colours.

Deflected solar wind

The flight of a hot air balloon

Pilot burns less fuel to descend balloon.

Pilot burns more propane to lift balloon into new wind direction.

Wind direction steers the balloon back.

Direction of the wind determines direction of balloon.

Lift off: Pilot burns propane gas into the balloon. Hot air rises.

Wind direction

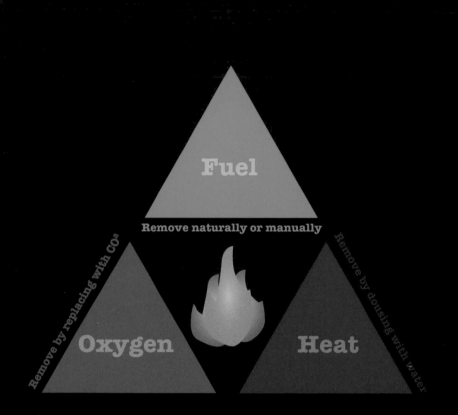

Fuel

Remove naturally or manually

Remove by replacing with CO_2

Remove by dousing with water

Oxygen

Heat

Fire triangle

To ignite and burn, a fire
requires three elements: heat,
fuel, and oxygen. Remove one
or more elements to put out
and prevent a fire.

Fires

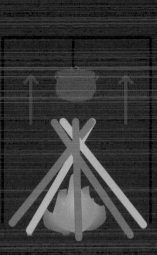

Log Cabin
Long lasting fire, well
ventilated from gaps in wood.

Tepee
Quick fire, directs
heat upwards.

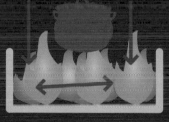

Trench
Good for cooking, blocks
and funnels wind for
concentrated heat.

Reflector
Focused heat direction,
reflects off surface.

Indigenous dwellings

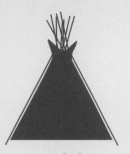

Tipi
Originally made of animal skins or birch bark. Well known to be used by Plains Indians.

Chum
Nomadic reindeer herders of north-western Russia. Similar to the Lavvu but bigger.

Beehive houses
A South African Zulu dwelling constructed of layers of thatch covering a framework of wooden strips. Placed in a circle.

Lavvu
Used by Sami people of northern Scandinavia. Similar to the Tipi but less vertical and better in winds.

Navajo hogan
The main home of the Navajo people. Traditionally curved and square, with a door facing east to welcome the rising sun, for good wealth and fortune.

Wigwam/Wickiups

Made from a wooden curved
frame this single-room dwelling
is used by some Native
American tribes.

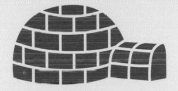

Igloo/Snowhouse

Shelters made from blocks of snow,
generally in the form of a dome.
Used by people in the central arctic
region and Greenland.

Humpy

Traditionally used by Australian
Aborigines. A shelter made
from bark and branches with a
standing tree usually used as the
main support.

Yaranga

Used in Northern Russia. A rounded
light wooden frame covered with
reindeer skins sewn together.

Yurt

Felt-covered, with a frame made of
wood lattice. Used by nomads in the
grasslands of Central Asia.

Energy used per hour

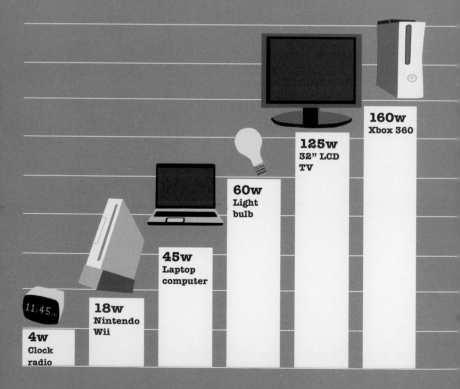

4w
Clock radio

18w
Nintendo Wii

45w
Laptop computer

60w
Light bulb

125w
32" LCD TV

160w
Xbox 360

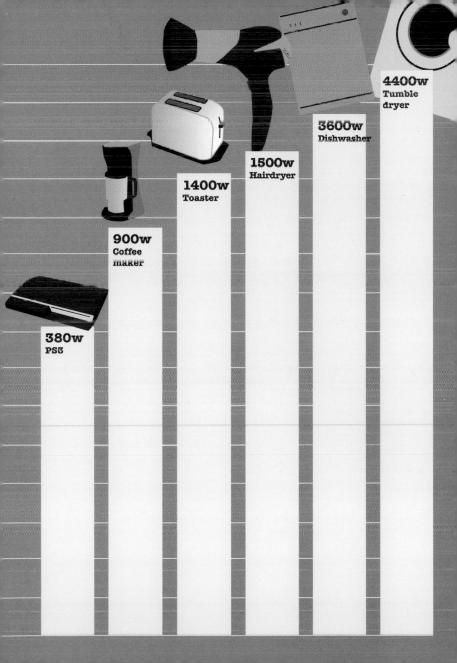

4400w
Tumble
dryer

3600w
Dishwasher

1500w
Hairdryer

1400w
Toaster

900w
Coffee
maker

380w
PS3

Make your own solar energy

1.

Place a copper sheet on top of an electric hob.

2.

As the copper heats bright colours appear because of oxidation.

3.

Heat for 30 minutes; the colour disappears, covered by cupric oxide.

4.

Allow to cool, the black cupric oxide will begin to flake off.

5.

Lightly remove
remaining black
cupric oxide.

Bend and place
in a jar with a
another sheet of
copper.

Add clip leads,
positive to
cupric oxide,
negative to the
new copper.

6.

Add some salt
water to
the jar.

Place in the
sun and attach
the ends of the
leads to an
electrical device.

Air

freshener:
Add equal amount of lemon juice and water to an atomiser **All purpose cleaner:** Add equal amounts of lemon juice and water to a spray bottle **Microwave:** Heat a bowl of water and lemon slices in your microwave for a minute; then wipe out the oven **Fridge:** Half a lemon stored in your fridge will control unpleasant smells **Limescale:** Use a halved lemon to clean the limescale off a sink or taps; rinse well **Drain cleaner:** Hot lemon juice and baking soda **Chopping boards:** Rub lemon juice into your wooden chopping board, leave overnight and then rinse **Glass and mirrors:** 4 tablespoons of lemon juice mixed with half a gallon of water makes an effective window cleaner **Furniture:** 2 parts olive oil or cooking oil mixed with 1 part lemon juice makes for an excellent furniture polish

Largest fruit and veg

Watermelon
122kg (269lbs)

Marrow
65kg (113lbs)

Cucumber 1.16m (46inches)

Cauliflower
14kg
(31.25lbs)

Apple
1.8kg (4lbs)

Tomato
3.5kg
(7.12lbs)

Crop Circles

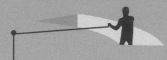

To create a circle attach a rope to a stake.

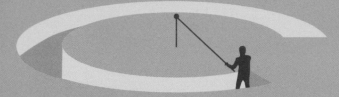

Follow the rope round, flattening the crop with a board.

Complete the circle.

Flatten the inside of the circle using the board.

King Arthur and the knights of the round table

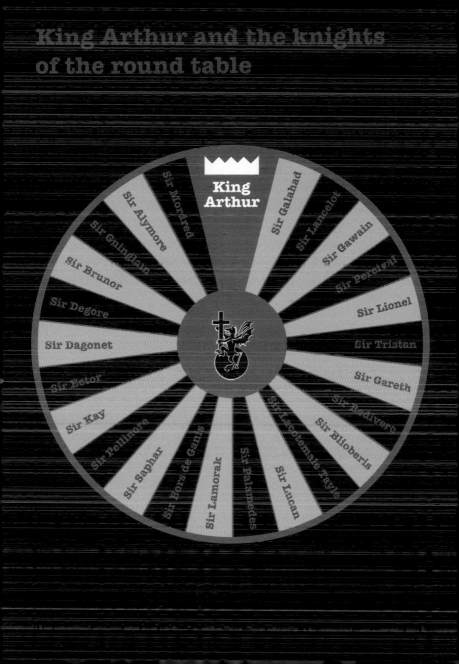

Stonehenge 2000BC

At sunrise on 21 June the
rising sun aligns with the
Heel stone and the Altar stone

Heel stone

Altar stone

Sarsen circle

N
E
W
S

Stonehenge present day

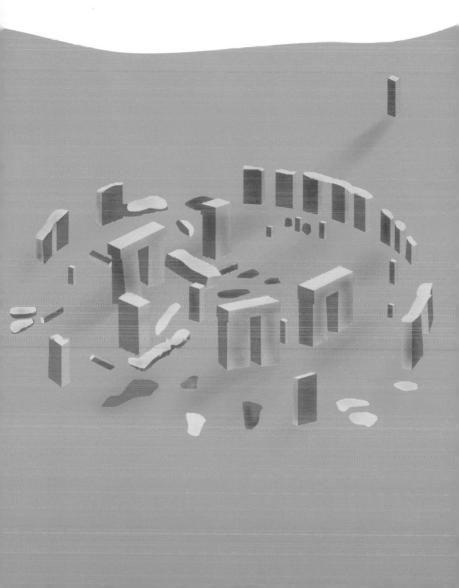

Hieroglyphic alphabet

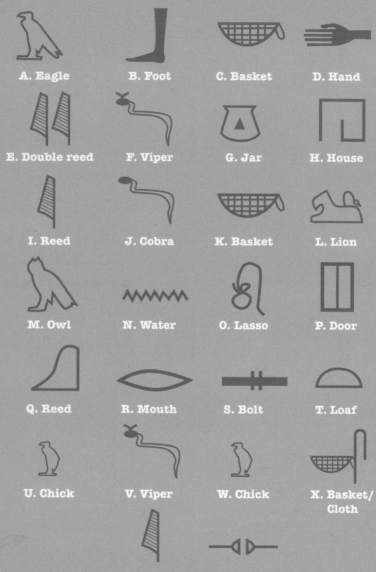

A. Eagle

B. Foot

C. Basket

D. Hand

E. Double reed

F. Viper

G. Jar

H. House

I. Reed

J. Cobra

K. Basket

L. Lion

M. Owl

N. Water

O. Lasso

P. Door

Q. Reed

R. Mouth

S. Bolt

T. Loaf

U. Chick

V. Viper

W. Chick

X. Basket/ Cloth

Y. Reed

Z. Cloth

Aztec Tonalpohualli calendar

Tonalpohualli calendars last 260 days,
made of 20 Aztec weeks, each with 13 days

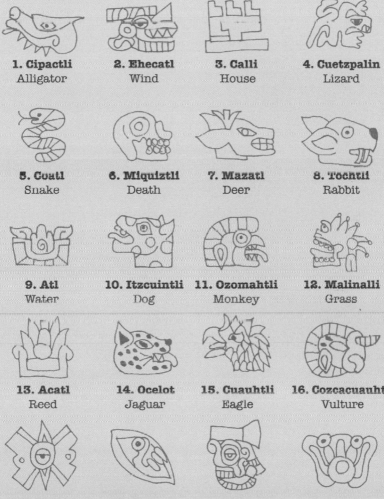

1. Cipactli
Alligator

2. Ehecatl
Wind

3. Calli
House

4. Cuetzpalin
Lizard

5. Coatl
Snake

6. Miquiztli
Death

7. Mazatl
Deer

8. Tochtli
Rabbit

9. Atl
Water

10. Itzcuintli
Dog

11. Ozomahtli
Monkey

12. Malinalli
Grass

13. Acatl
Reed

14. Ocelot
Jaguar

15. Cuauhtli
Eagle

16. Cozcacuauhtli
Vulture

17. Ollin
Movement

18. Tecpatl
Flint

19. Quiahuitl
Rain

20. Xochitl
Flower

Theories on pyramid building

Spiral ramp

Stone blocks were moved along an external ramp which corkscrewed around the outside of the pyramid.

Straight ramp

The ramp used to move the stone becomes longer as the pyramid becomes higher, keeping the incline the same.

Mummification

Head, fingers and toes wrapped with linen.

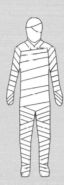

Arms and legs wrapped. Amulets placed between each layer.

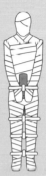

Arms and legs tied together. Scroll of spells placed between the hands.

More wrapping.

Picture of the god Osiris is painted on the surface.

Large cloth wrapped around the mummy and attached with strips. Mummy lowered into a first, then a second coffin.

Furoshiki

Traditional Japanese wrapping cloth

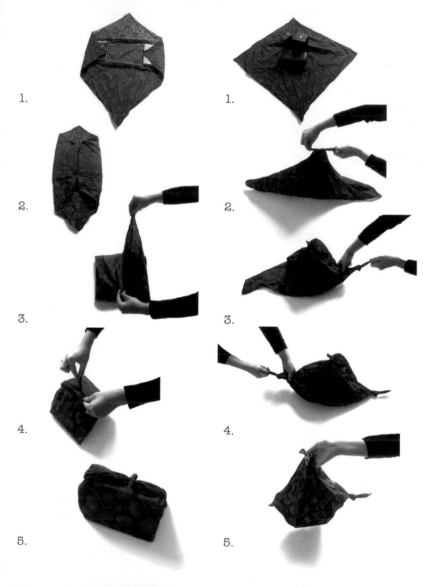

1.

2.

3.

4.

5.

1.

2.

3.

4.

5.

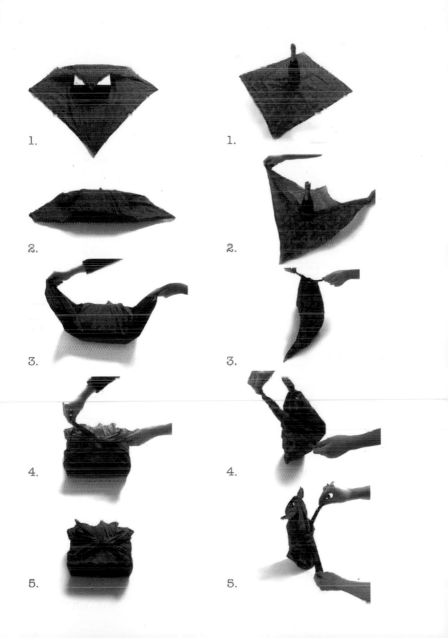

1.

2.

3.

4.

5.

1.

2.

3.

4.

5.

Folding a t-shirt

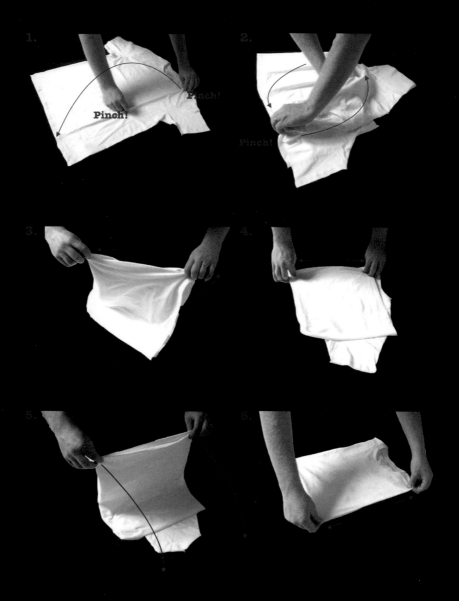

Dress shirt collars

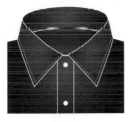

Classic

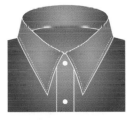

Narrow spread

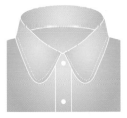

Rounded

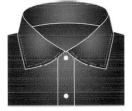

Curved spread

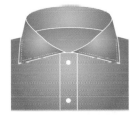

Full cut away

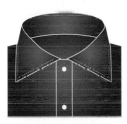

Half cut away

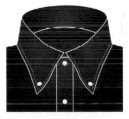

Button down

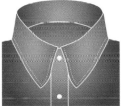

Tabbed

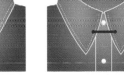

Pinned

Police hats

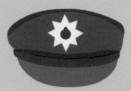

Turkey

Royal Barbados

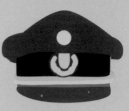

Austria

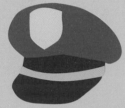

Mexico

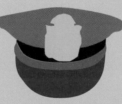

Thailand

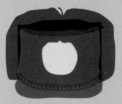

Ukraine

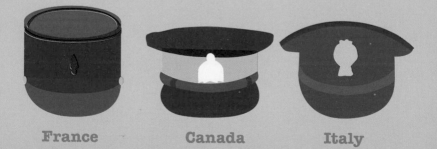

France

Canada

Italy

Russia

Finland

Egypt

The Netherlands

Bulgaria

Switzerland

United Kingdom

Sweden

South Africa

The assassination of JFK

Dallas, Texas, 12:30pm, Fri 22 Nov 1963

Grassy
Knoll

Zapruder
(Filmed the
assassination)

third shot

Limo (JFK)

Limo (JFK)

Altgens
(Photographer)

Moorman/Hill
(Witness)

Dealy
Plaza

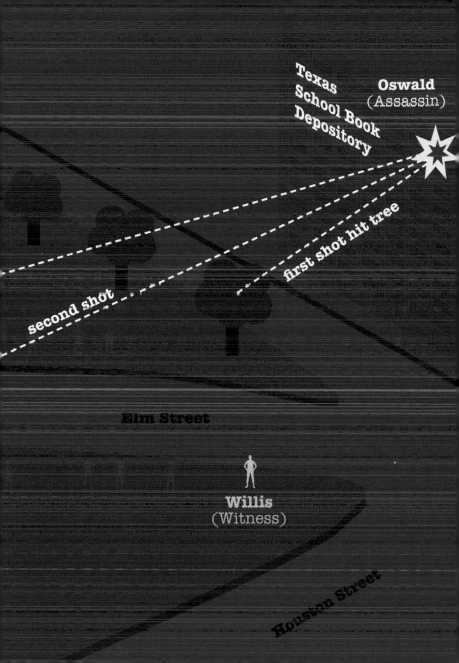

Outlaws

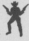

Bob Ford
1862-1892
Crime: Shot Jesse James
Death: Shot by Edward O'Kelley

. . . .

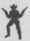

Edward Capehart O'Kelley
1858-1904
Crime: Murdered Robert Ford
Death: Shot by a policeman

. . . .

Jesse James
1847-1882
Crime: Bank robbery, murder,
waylaid stagecoaches and trains
Death: Shot by Robert Ford

. . . .

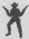

Butch Cassidy
1866-1908
Real name: Robert LeRoy Parker
Crime: Train and bank robbery
Death: Uncertain

. . . .

The Sundance Kid
1867-1908
Real name: Harry Longabaugh
Crime: Horse theft, train
and bank robbery
Death: Killed by the authorities

. . . .

Billy the Kid
1859-1881
Real name: William H Bonney
Crime: Theft and murder
Death: Shot by a sheriff

John Dillinger
1903-1934
Crime: Bank robbery
Death: Shot by FBI agents

. . . .

Baby Face Nelson
1908-1934
Real name: Lester Joseph Gillis
Crime: Bank robbery
Death: Shot by FBI agents

. . . .

Pretty Boy Floyd
1904-1934
Real name: Charles Arthur Floyd
Crime: Bank robbery and murder
Death: Shot by police

. . . .

Machine Gun Kelly
1895-1954
Real name: George Kelly Barnes
Crime: Bootlegging, armed
robbery, kidnapping
Death: Heart attack

. . . .

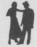

Bonnie and Clyde
Bonnie Elizabeth Parker
1910-1934
Clyde Chestnut Barrow
1909-1934
Crime: bank robberies, robbed
stores and gas stations, murder
Death: Shot by authorities

Prison population rates

per 100,000 of the population

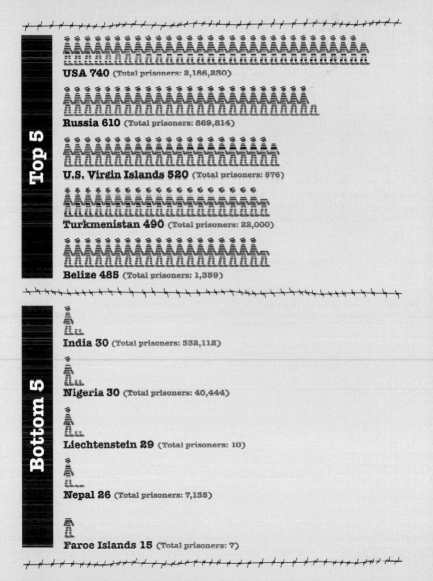

= 25 prisoners

Top 5

USA 740 (Total prisoners: 2,186,230)

Russia 610 (Total prisoners: 869,814)

U.S. Virgin Islands 520 (Total prisoners: 576)

Turkmenistan 490 (Total prisoners: 22,000)

Belize 485 (Total prisoners: 1,359)

Bottom 5

India 30 (Total prisoners: 332,112)

Nigeria 30 (Total prisoners: 40,444)

Liechtenstein 29 (Total prisoners: 10)

Nepal 26 (Total prisoners: 7,135)

Faroe Islands 15 (Total prisoners: 7)

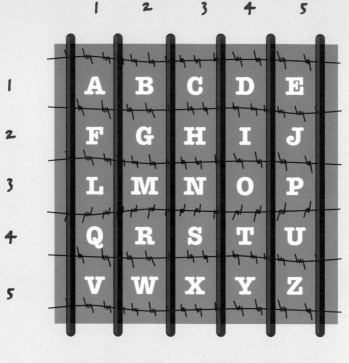

	1	2	3	4	5
1	A	B	C	D	E
2	F	G	H	I	J
3	L	M	N	O	P
4	Q	R	S	T	U
5	V	W	X	Y	Z

TAP CODE

4,4 1,1 3,5 1,3 3,4 1,4 1,5

The tap code is used by prisoners to
communicate with one another by tapping
either the metal bars or the walls inside
the cell. Each letter was communicated by
tapping two numbers: the first designated
the row (horizontal) and the second
designated the column (vertical). The letter
"X" was used to break up sentences.
Letter "K" is replaced with "C".

Morse code

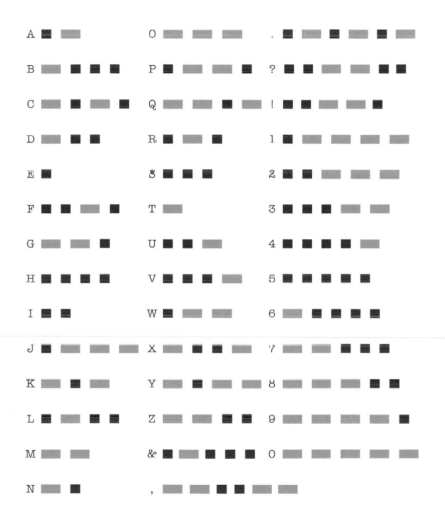

Web suffixes & dialling codes

GREENLAND
.gl 299

SWEDEN
.se 46

ICELAND
.is 354

NORWAY
.no 47

ESTO
LAT

UNITED
KINGDOM
.uk 44

DENMARK
.dk 45

LITHU
POLAN
.pl

CANADA
.ca 1

REPUBLIC
OF IRELAND
.ie 353

GERMANY
.de 49

CZECH
.cz 420

HOLLAND
31 .nl

SLOV
.sl

LUX
.lu 352

BELGIUM
.be 32

AUSTRIA
.at 43

HUNG
.hu 3

FRANCE
.fr 33

SWITZ
.ch 41

CROATIA
.

UNITED STATES OF AMERICA
.us 1

ANDORRA
.ad 376

ITALY
.it 370

ALBANI
.al 355

SPAIN
.es 34

PORTUGAL
.pt 351

VATICAN
.va 379

SERBIA
MONTEN
.cs 381

MALTA
.mt 356

MOROCCO
.ma 212

TUNISIA
.tn 216

ALGERIA
.dz 213

LIBY
.ly 218

WESTERN SAHARA
.eh 212

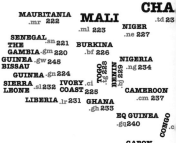

MAURITANIA
.mr 222

MALI
.ml 223

CHA
.td 23

NIGER
.ne 227

SENEGAL
.sn 221

THE
GAMBIA
.gm 220

BURKINA
.bf 226

NIGERIA
.ng 234

MEXICO
.mx 52

CUBA
.cu 53

DOMINICAN REPUBLIC
.do 1-809

HAITI
.ht 509

PUERTO RICO
.pr 1-787

BELIZE
.bz 501

JAMAICA
.jm 1-876

GUATEMALA
.gt 502

HONDURAS
.hn 504

EL
SALVADOR
.sv 503

NICARAGUA
.ni 505

GUINEA
.gw 245
BISSAU

GUINEA .gn 224

TOGO
.tg 228

BENIN
.bj 229

SIERRA
LEONE
.sl 232

IVORY
COAST
.ci 225

CAMEROON
.cm 237

COSTA RICA
.cr 506

PANAMA
.pa 507

VENEZUELA
.ve 58

GUYANA
.gy 592

FR.GUIANA
.gf 594

LIBERIA .lr 231

GHANA
.gh 233

EQ GUINEA
.gq 240

CONGO
.c

SURINAME
.sr 597

COLOMBIA
.co 57

GABON
.ga 241

ECUADOR
.ec 593

PERU
.pe 51

BRAZIL
.br 55

ANG
.ao 244

BOLIVIA
.bo 591

PARAGUAY
.py 595

CHILE
.cl 56

NAMIE
.na 2

B

ARGENTINA
.ar 54

URUGUAY
.uy 598

SOUT
AFRI
.za 27

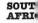

RUSSIA
.ru 7

l
᠌᠌᠌ 8
LARUS .by 375

RAINE .ua 380

.md 373
OVA
A .ro 40
A
KAZAKHSTAN .kz 7
GEORGIA
.ge 995
AZERBAIJAN
ARMENIA .az 994
UZBEKISTAN .uz 998
KYRGYZSTAN
.kg 996
MONGOLIA
.mn 976
N KOREA
.kp 850
JAPAN
.jp 81
RKEY .am 374
.tr 90
SYRIA .sy 963
TURKMENISTAN
.tm 993
TAJIKISTAN
.tj 992
S KOREA
.kr 82
LEBANON .lb 961
US
7
AEL
/2
.jo
962
JORDAN
IRAQ
.iq 964
KUWAIT
.kw 965
IRAN
.ir 98
AFGHANISTAN
.af 93
CHINA
.cn 86
YPT
g 20
BAHRAIN
.bh 973
QATAR
.qa 974
PAKISTAN
.pk 92
NEPAL
BHUTAN .bt 975
HONG KONG
.hk 852
TAIWAN
.tw 886
SAUDI ARABIA
.sa
966
UAE .ae 971
INDIA
.in 91
BANGLADESH
.bd 880
BURMA
.mm
95
.la 856
LAOS
PHILIPPINES
.ph 63
OMAN
.om 968
THAILAND
.th 66
UDAN
249
ERITREA
.er 291
YEMEN
.ye 967
SRI
LANKA
.lk 94
CAMBODIA
.kh 855
VIETNAM .vn 84
NTRAL
RICAN
?. .cf 236
MALAYSIA
.my 60
BRUNEI
.bn 673
ETHIOPIA
.et 251
SOMALIA
.so 252
SINGAPORE
.sg 65
GANDA
KENYA
.ug 256 .ke 254
TIMOR-LESTE
.tp 670
NEW
GUINEA
.gb 675
WANDA
.rw 250
URUNDI
.bi 257
TANZANIA
.tz 255
PAPUA
NEW
GUINEA
.pg 675
AUSTRALIA
.au 61
MALAWI
.mw 265
MBIA
a 260
BWE
263
MOZAMBIQUE
.mz 258
NEW ZEALAND
.nz 64
A
SWAZILAND
.sz 268
LESOTHO
.ls 766

Diving

(Are you) OK

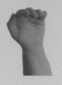

Come here

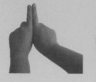

Stay together

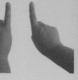

Move apart

**You lead
I'll follow**

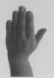

Stop

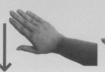

Slow down

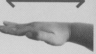

**Stay put at
this level**

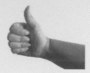

Up

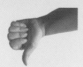

Down

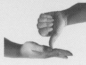

Descend to 10m

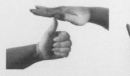

Ascend to 6m

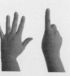

Where is your buddy?

signals

 Time

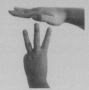 **Stop for 3 minutes**

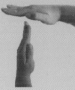 **Time out**

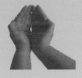 **Boat**

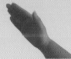 **This direction**

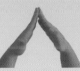 **Home**

 Not OK, something wrong

 Lion Fish

 Don't touch

 Turtle

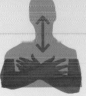 **I'm cold**

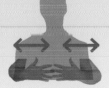 **I'm out of breath**

 Shark

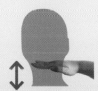 **Out of Air**

 I'm feeling effects of narcosis

 Look

Bridge types

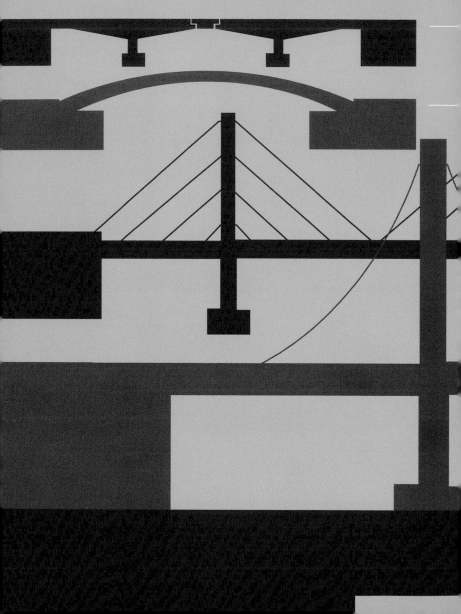

Cantilever
Longest: Quebec Bridge, Canada. 549 metres.

Arch
Longest: Lupa Bridge, Shanghai, China. 550 metres.

Cable-stayed
Longest: Sutong Bridge, Suzhou Nantong, China. 1088 metres.

Suspension
Longest: Akashi Kaikyo Bridge, Kobe-Awaji, Japan. 1991 metres.

Beam
Longest: Lake Pontchartrain Bridge, Louisiana, USA. 38,624 metres.

Long rivers and canals big lakes and reservoirs

10. Mississippi
3,733km

3. The Grand Union Canal
220km

3. Rideau Canal
200km

7. Great Bear Lake
31,080km²

9. Great Slave Lake
28,930km²

3. Lake Superior
82,414km²

3. Lake Michigan
117,702km²

10. Lake Erie
25,719km²

1. Caspian Sea
371,000km²

5. Panama Canal
82km

2. Smallwood Reservoir
6,527km²

1. Lake Volta
8,502km²

4. Suez Canal
163km

4. Lake Kariba
5,580km²

2. Amazon River
6,400km

1. Nile River
6,695km

3. Kuybyshev Reservoir
6,450 km²

4. Yenisei-Angara
6,550km

9. Lena
4,260km

5. Bukhtarma Reservoir
5,490km²

6. Ob-Irtysh
5,410km

8. Amur
4,410km

6. Lake Baikal
31,500km²

5. Huang He
5,464km

4. Lake Victoria
59,485km²

5. Tanganyika
32,893km²

8. Malawi
30,044km²

3. Yangtze
6,300km

1. The Grand Canal of China

7. Congo River
4,380km

Surviving without water

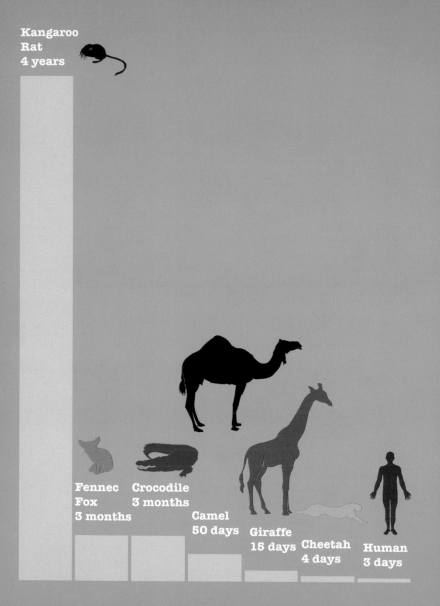

Kangaroo Rat
4 years

Fennec Fox
3 months

Crocodile
3 months

Camel
50 days

Giraffe
15 days

Cheetah
4 days

Human
3 days

Composition of the human body

Oxygen-65%

Carbon-18%

Hydrogen-10%

Nitrogen-3%
Calcium-1.5%
Phosphorus-1.3%
Other-1.2%

Tree of life

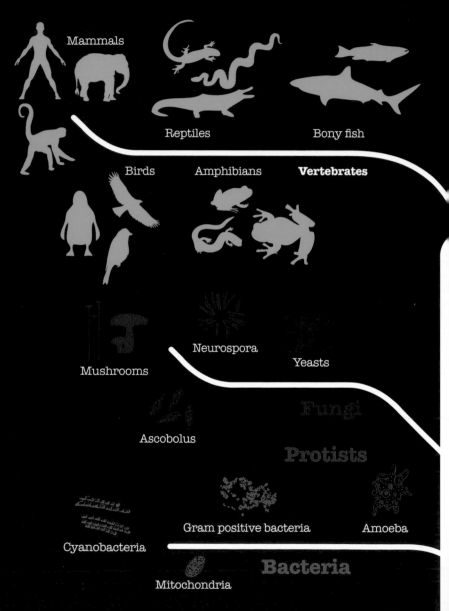

Mammals

Reptiles

Bony fish

Birds Amphibians **Vertebrates**

Neurospora

Yeasts

Mushrooms

Fungi

Ascobolus

Protists

Gram positive bacteria Amoeba

Cyanobacteria

Bacteria

Mitochondria

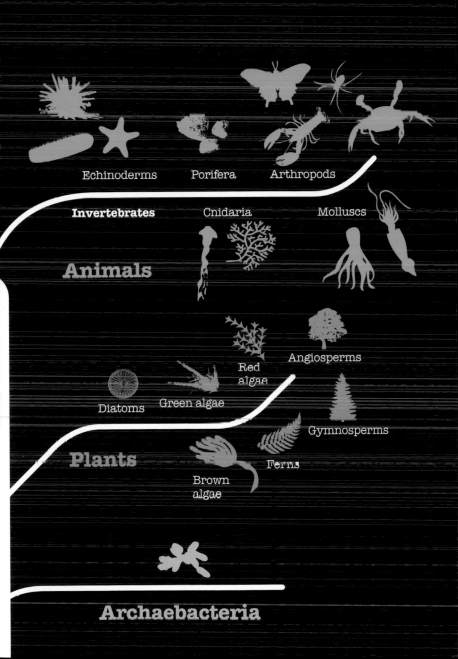

Echinoderms Porifera Arthropods

Invertebrates Cnidaria Molluscs

Animals

Red
algae Angiosperms

Diatoms Green algae

Gymnosperms

Plants Ferns

Brown
algae

Archaebacteria

Human ancestry—Genus Homo

3 (Millions of years ago) **2**

Homo Habilis
(Skillful Human)

Homo Rudolfensis

Homo Ergaster

Homo Erectus
(Upright Human)

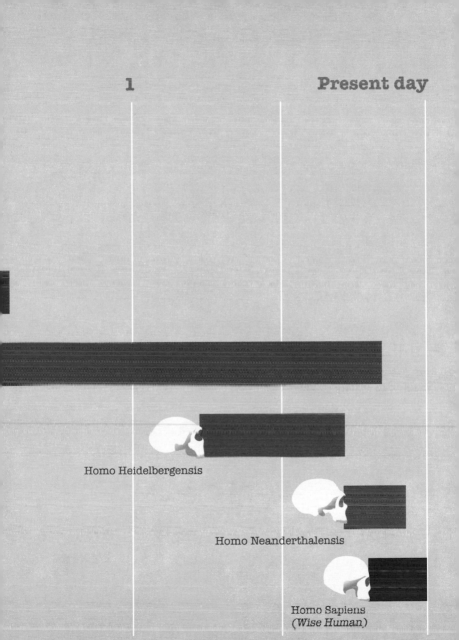

1 Present day

Homo Heidelbergensis

Homo Neanderthalensis

Homo Sapiens
(Wise Human)

Extinct animals

Big-Eared Hopping Mouse Extinct in 1843. South-Western Australia

Steller's Sea Cow Extinct in 1768. Bering Sea

Dodo Extinct in 1681. Mauritius

No sightings

Passenger Pigeon Last seen in 1914. Native to North America

Barbary Lion Last seen in 1942. Native to North Africa

Yangtze River Dolphin Last seen in 2004. Native to China

Endangered animals

Marquesan Kingfisher Population approx 950. Native to Marquesas Islands

Giant Panda Population approx 1,500. Native to China

Elephant Population approx 35,000. Native to Africa and Asia

Giant Saddleback Tortoise Extinct in 1795. Native to Galápagos Islands

Giant Sloth Extinct in 1620. Native to North and South America

Syrian Wild Ass Last seen in 1928. Native to Asia

Caspian Tiger Last seen in 1997. Native to Asia and Western Europe

Gorilla Population approx 125,000. Native to Africa

Blue Whale Population approx 12,000. Native to Indian Ocean and South Pacific

Cryptozoology (legendary creatures)

Ogopogo
Lake monsters
Okanagan Lake,
Canada

Champ
Prehistoric-
looking creatures
Lake Champlain,
USA

**Sasquatch/
Bigfoot**
Hairy hominoid
Pacific Northwest,
USA

**Loch Ness
Monster**
Lake monster
Scotland

Caddy
Sea serpents
West coast of
Canada

Jersey Devil
Winged
creature
New Jersey,
USA

Beast of Bodmin
Large cats
England

Bobo
Sea monsters
North Pacific Ocean

Honey Island Swamp Monster
"Swamp Thing" monsters
Louisiana, USA

Ucu
Hairy hominoid
Andean foothills,
South America

Andean Wolf
Mountain dogs
South America

Lake Seljord Monster
Lake monster
Norway

Yeti/Abominable Snowman
Rock apes
Himalayas

Mongolian Death Worm
Giant snakes/worms
Gobi Desert, Mongolia

Tazelwurm
Reptilian
European Alps

Yeren
Reddish wildmen
China

Almas
Huge hairy creature
Euroasia

Arabhar
Flying snakes
Arabian Sea region

Buru
Bluish black giant lizards
Himalayas

Agogwe
Little, human-like, hairy
bipeds Eastern Africa

Ahool
Unknown giant
bats Java

Ebu Gogo
Small hairy people
Indonesia

Yowie
Tall hairy hominoids
Australia

Blue Mountain Panthers
Large black cats
Australia

Creatures from Greek mythology

Hydra
Serpent beast with nine or more heads

Pegasus
Winged horse

Harpy
Winged death spirit

Medusa
Gorgon with hair of snakes

Minotaur
Half-man half-bull

Cerberus
Multi-headed dog

Centaur
Half-man half-horse

Bermuda

Miami

Bermuda triangle

Puerto Rico

Alleged aircraft disappearances

1945 US Navy Flight 19
1945 US Navy PBM-5 Mariner
1947 US Army C-54
1948 BSA Airways Avro Tudor IV
1948 Douglas DC-3 NC16002
1950 F6F-5 Hellcat
1950 F9F-2 Panther
1950 US Air Force Globemaster
1952 BSA Airways Avro York
1952 C-46 Commando
1953 US Navy T2V SeaStar
1954 US Navy R7V-1 Super Constellation
1956 US Navy P5M Marlin seaplane
1959 Beechcraft Bonanza N4952B
1960 US Air Force F-100 Super Sabre
1961 US Air Force SAC B-52 bomber
1962 US Air Force KB-50 Aerial Tanker
1962 US Air Force C-133 Cargomaster

1963 2 US Air Force KC 135
1963 US Air Force C-133 Cargomaster
1965 US Air Force C-119 Flying Boxcar
1966 Privately owned B-25 Mitchell
1969 Cessna 172
1971 US Air Force F-4 Phantom II Sting 27
1973 Ryan Navion
1974 Piper Cherokee
1978 US Navy KA-6D Fighting Tiger 524
1978 Argosy Airlines Douglas DC-3
1978 Caribbean Flight 912
1980 Beechcraft Baron N9027Q
1980 ERCO Ercoupe N3808H
1981 Beechcraft Bonanza N5805C
1986 Piper Cherokee N3527E
2003 Piper PA-323-300 N8224C
2005 Piper PA-23 N6886Y
2007 Piper PA-46-310P N444JH

North Pole exploration

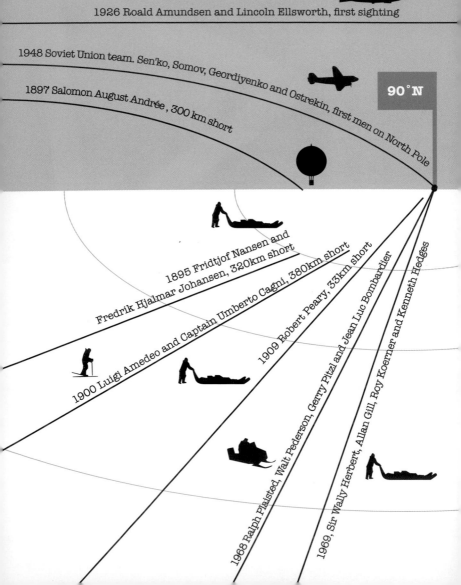

1926 Roald Amundsen and Lincoln Ellsworth, first sighting

1948 Soviet Union team. Sen'ko, Somov, Geordiyenko and Ostrekin, first men on North Pole

1897 Salomon August Andrée , 300 km short

90°N

1895 Fridtjof Nansen and Fredrik Hjalmar Johansen, 320km short

1900 Luigi Amedeo and Captain Umberto Cagni, 380km short

1909 Robert Peary, 33km short

1968 Ralph Plaisted, Walt Pederson, Gerry Pitzl and Jean Luc Bombardier

1969, Sir Wally Herbert, Allan Gill, Roy Koerner and Kenneth Hedges

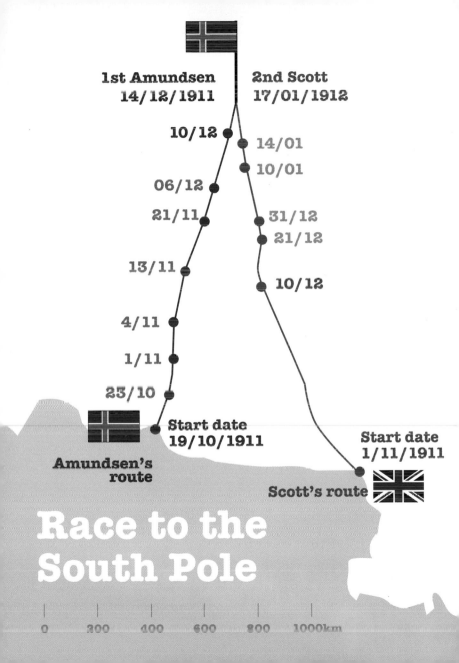

1st Amundsen
14/12/1911

2nd Scott
17/01/1912

10/12

14/01

10/01

06/12

21/11

31/12

21/12

13/11

10/12

4/11

1/11

23/10

Start date
19/10/1911

Start date
1/11/1911

Amundsen's
route

Scott's route

Race to the South Pole

0 200 400 600 800 1000km

New York City Subway geographic map

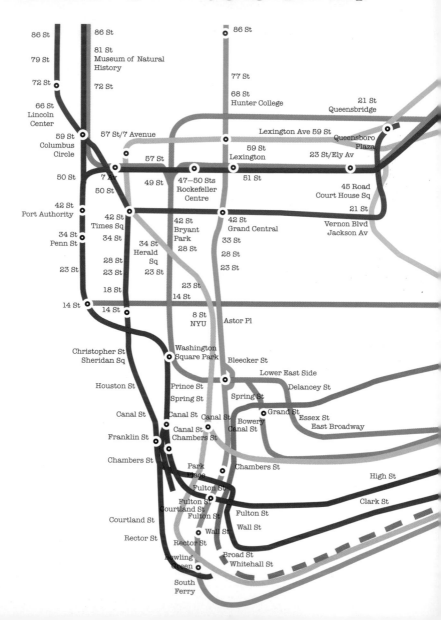

86 St

86 St

86 St

79 St

81 St
Museum of Natural
History

77 St

72 St

72 St

68 St
Hunter College

21 St
Queensbridge

66 St
Lincoln
Center

Lexington Ave 59 St

59 St
Columbus
Circle

57 St/7 Avenue

Queensboro
Plaza

59 St
Lexington

23 St/Ely Av

57 St

50 St

7 Av

49 St

47–50 Sts
Rockefeller
Centre

51 St

45 Road
Court House Sq

50 St

21 St

42 St
Port Authority

42 St
Times Sq

42 St
Bryant
Park

42 St
Grand Central

Vernon Blvd
Jackson Av

34 St
Penn St

34 St

34 St
Herald
Sq

28 St

33 St

28 St

28 St

23 St

28 St

23 St

23 St

23 St

23 St

18 St

23 St
14 St

14 St

14 St

8 St
NYU

Astor Pl

Christopher St
Sheridan Sq

Washington
Square Park

Bleecker St

Lower East Side

Houston St

Prince St

Delancey St

Spring St

Spring St

Canal St

Canal St

Canal St

Grand St

Essex St

Bowery
Canal St

East Broadway

Franklin St

Canal St
Chambers St

Chambers St

Park
Place

Chambers St

High St

Fulton St

Clark St

Fulton St
Courtland St

Fulton St

Fulton St

Courtland St

Wall St

Wall St

Rector St

Rector St

Bowling
Green

Broad St
Whitehall St

South
Ferry

London Underground geographic map

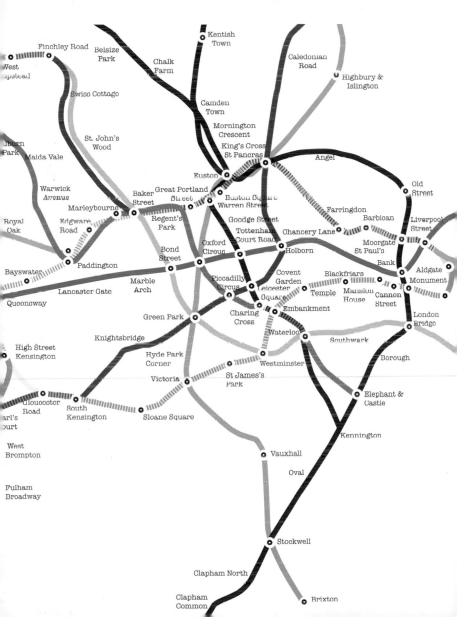

The world's largest roadside attractions

Pineapple
Woombye, Queensland,
Australia
16m (52ft) tall

Orange
Berri, South Australia
15m (50ft) tall

Guitar
Tamworth, Australia
12m (40ft) tall

Chair
Anniston, Alabama, USA
10m (33ft) tall

Baseball bat
Edmonton, Alberta, Canada
15m (50ft) tall

Thermometer
Baker, California, USA
41m (134ft) tall

Rocking horse
Adelaide, Australia
18m (60ft) tall

Easel
Goodland, Kansas, USA
24m (80ft) tall

Paperclip
Kipling, Canada
4.5m (15ft) wide

Route 66

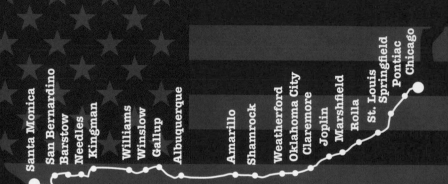

Santa Monica
San Bernardino
Barstow
Needles
Kingman
Williams
Winslow
Gallup
Albuquerque
Amarillo
Shamrock
Weatherford
Oklahoma City
Claremore
Joplin
Marshfield
Rolla
St. Louis
Springfield
Pontiac
Chicago

Orient Express

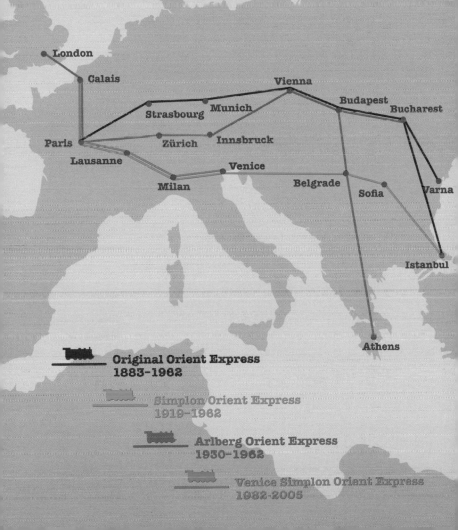

London
Calais
Vienna
Budapest
Bucharest
Strasbourg
Munich
Paris
Zürich
Innsbruck
Lausanne
Venice
Varna
Milan
Belgrade
Sofia
Istanbul
Athens

Original Orient Express
1883-1962

Simplon Orient Express
1919-1962

Arlberg Orient Express
1930-1962

Venice Simplon Orient Express
1982-2005

Historic empires

Mongolian Empire in 1268

Spanish Empire in 1759

Portuguese Empire in 1824

British Empire in 1922

French Empire in 1938

World languages

North America
English 70%
Spanish 9%, Mandarin 2%, French 2%
Others 17%

South America
Spanish 58%
Portuguese 33%
Creole 2%, English 1%
Others 6%

Europe (including Russia)

Russian 22%

German 12%

Turkish 9%, English 8%, Italian 8%
French 8%, Polish 6%, Spanish 6%
Ukrainian 4%

Others 17%

Asia & Pacific

Mandarin 34%

Hindustani 12%
Bengali 8%
Indonesian 6%
Japanese 3%
Punjabi 5%

Others 34%

Africa

Arabic 17%

Swahili 8%, French 6%
English 4%, Kwa 4%, Hausa 3%

Others 58%

Population of cities (in millions)

	7	8	9	10

- Shanghai (China)
- Mumbai (India)
- Beijing (China)
- São Paulo (Brazil)
- Moscow (Russia)
- Seoul (South Korea)
- Delhi (India)
- Karachi (Pakistan)
- Istanbul (Turkey)
- Jakarta (Indonesia)
- Mexico City (Mexico)
- Tokyo (Japan)
- New York City (USA)

Surname top tens

	USA	UK	Ireland
01	Smith	Smith	Murphy
02	Johnson	Jones	Kelly
03	Williams	Williams	O'Sullivan
04	Jones	Brown	Walsh
05	Brown	Taylor	Smith
06	Davis	Davis	O'Brien
07	Miller	Evans	Byrne
08	Wilson	Wilson	Ryan
09	Moore	Thomas	O'Connor
10	Taylor	Johnson	O'Neill

	India	China	Japan
01	Patel	Wáng	Sato
02	Shah	Lǐ	Suzuki
03	Kapoor	Zhāng	Takahashi
04	Khan	Liú	Tanaka
05	Mehra	Chén	Watanabe
06	Khanna	Yáng	Itou
07	Arora	Huáng	Yamamoto
08	Ahmed	Zhào	Nakamura
09	Kaur	Zhōu	Kobayashi
10	Qureshi	Wú	Saitou

Germany	France	Sweden	
Müller	Martin	Johansson	01
Schmidt	Bernard	Andersson	02
Schneider	Dubois	Karlsson	03
Fischer	Thomas	Nilsson	04
Meyer	Robert	Eriksson	05
Weber	Richard	Larsson	06
Schulz	Petit	Olsson	07
Wagner	Durand	Persson	08
Becker	Leroy	Svensson	09
Hoffmann	Moreau	Gustafsson	10

Italy	Spain	Argentina	
Rossi	García	Fernández	01
Russo	Fernández	Rodríguez	02
Ferrari	González	González	03
Esposito	Rodríguez	García	04
Bianchi	López	López	05
Romano	Martínez	Martínez	06
Colombo	Sánchez	Pérez	07
Ricci	Pérez	Álvarez	08
Marino	Martín	Gómez	09

80th Oak
70th Platinum
65th Sapphire

60th Diamond
50th Gold
40th Ruby

35th Coral 30th Pearl
25th Silver
20th China 15th Crystal
12th Silk

10th Tin 9th Copper
8th Salt 7th Wool 6th Sugar
5th Wood 4th Flower
3rd Leather 2nd Paper
1st Cotton

Wedding anniversaries

Toasting

Spanish	Salud
English	Cheers
Albanian	Gezuar
Arabic	Fisehatak
German	Prost
Iranian	Vashi
Chinese	Gan bei
Croatian	Zivjeli
Danish	Skaal
Estonian	Tervist
Finnish	Kippis
French	Santé
Hawaiian	Hipahipa
Indonesian	Pro
Italian	Salute
Japanese	Kampai
Norwegian	Skal
Portuguese	Saúde
Swahili	Afya
Thai	Choc-tee
Vietnamese	Chia
Zulu	Oogy wawa

Champagne making

pop

Select a Cuvée
(wine made from
either Chardonnay,
Pinot Meunier
or Pinot Noir grapes,
or a blend of).

Add yeast and sugar,
and seal with cap.

After a few years
of fermentation the
alcohol content will
increase and CO_2
will dissolve into
the wine, creating
the bubbles.

Turn upside down
so dead yeast cells
gather in neck.
Freeze the neck.

Remove cap and
frozen dead yeast
cells pop out.

Top up with sweet
wine and cork.

Champagne bottles

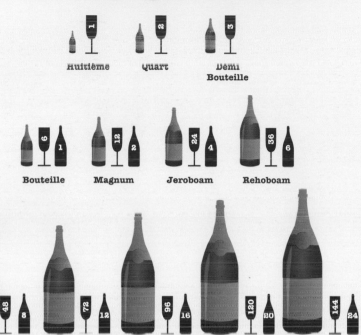

Huitième | Quart | Demi Bouteille

Bouteille | Magnum | Jeroboam | Rehoboam

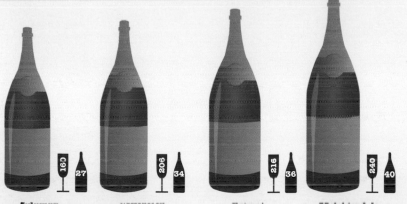

Methuselah | Salmanazar | Balthazar | Nebuchadnezzar | Melchior

Solomon | Sovereign | Drimat | Melchizedek

Glasses

Shot

Brandy

Sherry

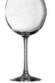

Wine

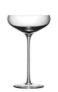

Coupe

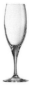

Flute

Martini

Hurricane

Pina colada

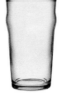

Margarita

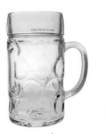

A Yard

Highball

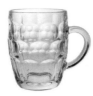

Britannia pint

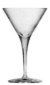

Nonic pint

Stein

Curing a hangover

Bloody Mary
30ml (1oz) Vodka
150ml (5oz) Tomato juice
2ml (0.06oz) Lemon juice
2 dashes Worcestershire sauce
2 dashes Tabasco sauce
Celery stalk
Lime wedge
Mix.

Prairie Oyster
1 Egg
1 dash Worcestershire sauce
Salt and black pepper
Crack the egg into a glass without
breaking the yolk. Down in one.

Hair of the Dog
120ml (4oz) Scotch
60ml (2oz) Honey
60ml (2oz) Cream
Mix.

Irish Breakfast
1 Espresso
2 Eggs
200ml (6.5oz) Guinness
200ml (6.5oz) Milk
Mix, drink cold.

Bloody Beer
165ml (5.5oz) Beer
Dash of Lemon juice
5 dashes Worcestershire sauce
5 dashes Tabasco sauce
150ml (5oz) Tomato juice
1 Egg.

Vodka Freeze
52ml (1.8oz) Vodka
26ml (0.9oz) Orange juice
26ml (0.9oz) Lemonade
Ice
Blend.

Coffees

Espresso

Espresso con Panna

Macchiato

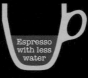

Ristretto

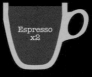

Doppio

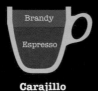

Carajillo

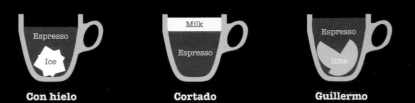

Con hielo

Cortado

Guillermo

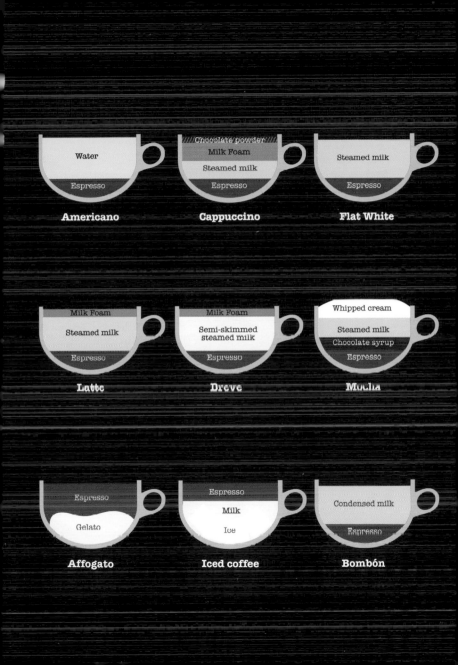

Americano

Water

Espresso

Cappuccino

Chocolate powder

Milk Foam

Steamed milk

Espresso

Flat White

Steamed milk

Espresso

Latte

Milk Foam

Steamed milk

Espresso

Breve

Milk Foam

Semi-skimmed
steamed milk

Espresso

Mocha

Whipped cream

Steamed milk

Chocolate syrup

Espresso

Affogato

Espresso

Gelato

Iced coffee

Espresso

Milk

Ice

Bombón

Condensed milk

Espresso

Breakfasts

Spain
Chocolate and churros
Fried dough dipped into
hot, thick chocolate

America
Pancakes and bagels

China
Rice porridge and
steamed pork dumplings

Sweden
Knackebrod and gravadlax
Rye, white and brown
bread and knackebrod to
make smorgasar—open
sandwiches

Turkey
Bread, butter, jam,
honey, olives, tomatoes,
cucumbers, cheese,
yogurt and preserved
meat

Japan
Steamed rice, miso soup,
grilled fish, omelet,
pickles, dried seaweed,
nalto and onsen tamago

France
Croissants, Pain au chocolat

Vietnam
Pho
Noodle soup with beef
or chicken

Egypt
Fava bean stew
Mashed brown fava beans
cooked with olive oil,
parsley and onion

Indonesia
Nasi goreng
Rice with mild curry,
vegetable and chicken
or prawns

Iran
Halim
Wheat, cinnamon,
butter and sugar cooked
with shredded chicken
or lamb

United Kingdom
Fried egg, black pudding,
sausages, tomato, baked
beans and fried toast

Cheese

Paneer

Cottage

Fresh
Curdled milk
moulded into the
form of cheese

Ricotta

Mozzarella

Hervé

Soft
High moisture
content and less
pressure in the
mould for a short
period of time

Pont l'Évêque

Camembert

Brie

Parmesan

Emmental

Pressed
Low moisture content
and more pressure in
the mould for a long
period of time

Cheddar

Gruyère

Stilton

Danish blue

Blue
Veined
Penicillium cultures
added to create the
veins

Gorgonzola

Roquefort

Pasta

Cavatappi

Calamari

Anellini

Conchiglie Rigate

Fusilli

Zita

Lasagna

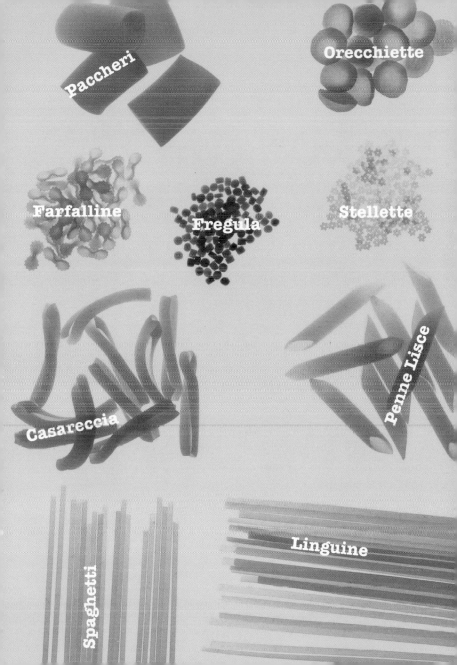

Paccheri

Orecchiette

Farfalline

Fregula

Stellette

Casareccia

Penne Lisce

Spaghetti

Linguine

Spices

Cumin
MATCHES: Beans, chicken, curry, lamb, lentils, peas, pork potatoes, rice, sausages, soups, stews and egg

Saffron
MATCHES: Chicken, curries, fish, lamb, mussels, paella, rice, risotto, shellfish, soup and tomatoes

Turmeric
MATCHES: Beans, chicken, curry, lamb, lentils, paella, rice and shellfish

Cardamom
MATCHES: Chicken, coffee, curries, duck, lentils, meat, oranges, peas and rice

Cloves
MATCHES: Apples, beans, game, ham, pumpkin, sausages, tea, tomatoes, walnut and wine

Cinnamon
MATCHES: Apples, berries,
chicken, chocolate, coffee,
custards, lamb, oranges,
pears and rice

Coriander
MATCHES: Curry, fish,
ham, lamb, lentils,
pork, stuffing, tomatoes
and turkey

Caraway Seeds
MATCHES: Bread,
cabbage, cheese, pork,
potatoes, sausages,
soups and turnips

Chili Powder
MATCHES: Beans,
casseroles, meat, poultry,
seafood, rice and tomatoes

Paprika
MATCHES: Cauliflower,
chicken, crab, fish,
lamb, potatoes, rice,
shellfish and veal

The Scoville rating of pepper hotness

Naga jolokia pepper
855,000–1,050,000

Red savina pepper
350,000–580,000

Habanero chili
100,000–350,000

Thai pepper
50,000–100,000

Tabasco pepper
30,000–50,000

Serrano pepper
10,000–23,000

Jalapeño pepper
2,500–8,000

Anaheim pepper
500–2,500

Pimento pepper
100–500

Bell pepper
0

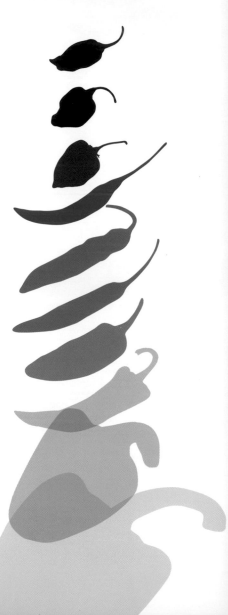

Common cooking herbs

Dill
fish, eggs, tomato dishes

Tarragon
fish, chicken, seafood

Sage
poultry, cheeses

Rosemary
lamb, rabbit,
vegetables

Mint
tea, sauces, lamb

Chives
salads, garnish,
potatoes

Thyme
tomato, meats, eggs

Vitamin	Source	Uses	Deficiency
A	Dairy products, eggs, liver, green vegetables, carrot	Maintains the health of the epithelium and helps the eye's dark adaptation	Keratinisation of the nasal and respiratory passage epithelium, night blindness
B1	Yeast, egg yolk, liver, wheatgerm, nuts, red meat, cereals	Carbohydrate metabolism	Fatigue, irritability, loss of appetite; severe deficiency can lead to beri-beri
B2	Dairy products, liver, vegetables, eggs, cereals, fruit, yeast	Intracellular metabolism	Painful tongue and fissures to the corners of the mouth, chapped lips
B12	Liver, red meat, dairy products, fish	Manufacturing of genetic material in cells. Involved in the production of erythrocytes	pernicious anaemia
C	Green vegetables, fruit	Maintenance of bones, teeth and gums, ligaments and blood vessels. Immune system	Scurvy
D	Fish liver oils, dairy produce, sunlight	Absorption of calcium, for the maintenance of healthy bones	Rickets
E	Pure vegetable oils, wheatgerm, wholemeal bread and cereals, egg yoke, nuts sunflower seeds	Protects tissues against damage; promotes normal growth and development; helps in normal red blood cell formation	May cause muscular dystrophy
K	Green vegetables	Used by the liver for the formation of prothrombin	Delays clotting times of blood. Easy bruising and nosebleeds

A Tudor banquet

1st Course

Jugged hare
Stuffed chicken
Loin of veal
Roast tongue
Vegetables
Bread

3rd Course

Deer
Pig
Goslings
Pigeon
Rabbit
Heron
Wild boar
Leveret
Vegetables
Bread

3rd Course

Wafers
Coloured jelly

4th Course

Strawberries
Plums
Cheese
White cream

5th Course

Wines
Pastries

Church
Landowner

Archbishops
Part of government

Bishops

Clergymen

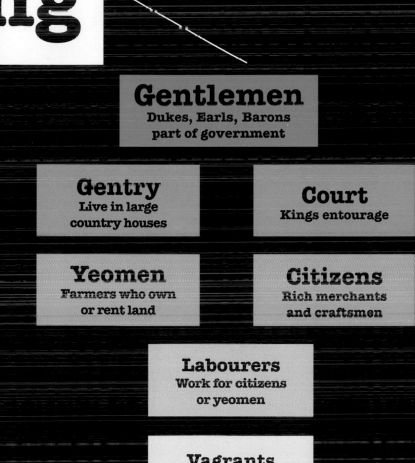

16th century Baroque gardens

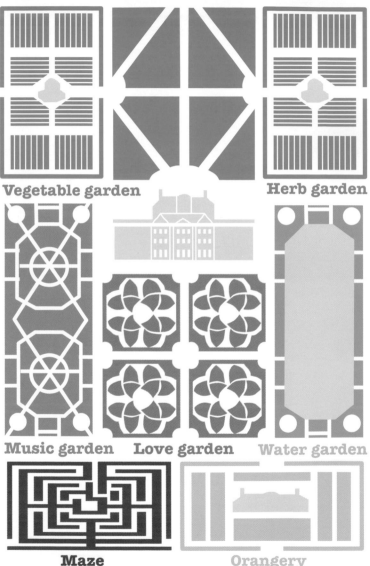

Vegetable garden

Herb garden

Music garden

Love garden

Water garden

Maze

Orangery

Butterflies

Swallowtails (Papilionidae)

Tiger Swallowtail
North America

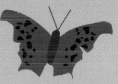

Common Buckeye
United States

Question Mark
North America

Brush-Footed (Nymphalidae)

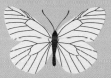

Scarce Swallowtail
Southern Europe

Gossamer-Winged (Lycaenidae)

Whites and Sulphurs (Pieridae)

Black-Veined White
Europe and Northern Africa

Large Marble
North America

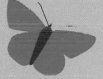

Common Blue
Ireland and Scotland

Red Pierrot
South Asia

Metalmarks (Riodinidae)

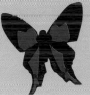

Tailed metalmark
Central and South America

Skippers (Hesperiidae)

Gold-Drop Helicopis
North America

Large Chequered Skipper
Europe

Wild Indigo Duskywing
United States

Frogs and jellyfish

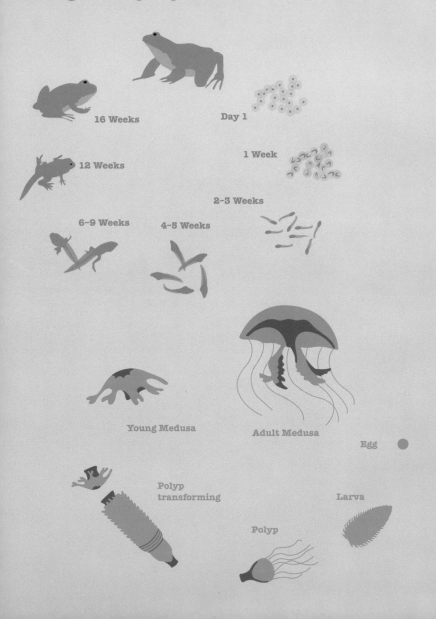

16 Weeks

Day 1

12 Weeks

1 Week

2-3 Weeks

6-9 Weeks 4-5 Weeks

Young Medusa Adult Medusa

Egg

Polyp
transforming Larva

Polyp

Boiling the perfect egg

12cm circumference egg

Yolk	Time
Runny	3:00
Medium	3:40
Hard	4:30

Add 30 secs if fridge cold

14cm circumference egg

Yolk	Time
Runny	4.00
Medium	4:50
Hard	6:00

Add 40 secs if fridge cold

16cm circumference egg

Yolk	Time
Runny	5:20
Medium	6:20
Hard	7:50

Add 60 secs if fridge cold

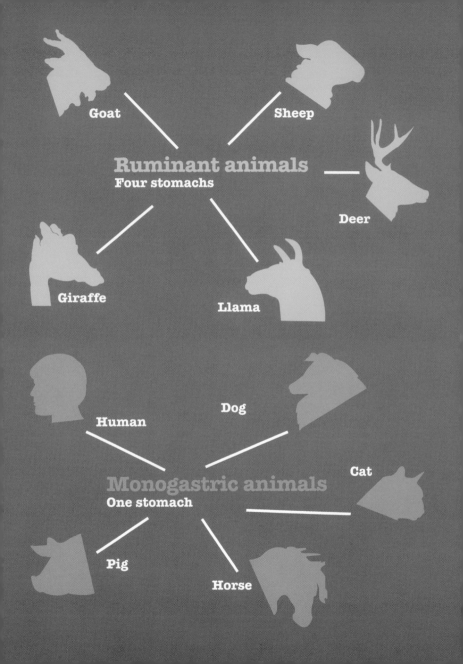

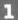

Ruminant stomach

1 Rumen
Food partially broken down by bacteria.

2 Reticulum
Food passes through the reticulum where the animal can regurgitate and reprocess the matter.

3 Omasum
Food is broken down further.

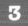

4 Abomasum
The abomasum secretes gastric juices which aid digestion (known as the true stomach working the same as a monogastric stomach).

Monogastric stomach

1 Stomach Ingested parasites and bad bacteria are killed, food is broken into smaller particles and made easier to digest.

Mouse: 19 days
Adult: 25g (0.9oz)
New born: 5g (0.18oz)
New born name: Pup
Walking age of young: 2 weeks

Ostrich: 42 days
Adult: 130kg (287lbs)
New born: 1.4kg (3.1lbs)
New born name: Chick
Walking age of young: 1-2 minutes

Lion: 108 days
Adult: 200kg (440lbs)
New born: 14kg (3lbs)
New born name: Cub
Walking age of young: 2 weeks

Brown bear: 220 days
Adult: 400kg (882lbs)
New born: 0.5kg (1lbs)
New born name: Cub
Walking age of young: 8-12 weeks

Human: 266 days
Adult: 83kg (183lbs)
New born: 3.2kg (7lbs)
New born name: Baby
Walking age of young: 10-13 months

Giraffe: 457 days
Adult: 1,300kg (2,866lbs)
New born: 55kg (120lbs)
New born name: Calf
Walking age of young: within 1 hour

Gestation periods

Elephant: 645 days
Adult: 3,500kg (7,716lbs)
New born: 113kg (249lbs)
New born name: Calf
Walking age of young: within 1 hour

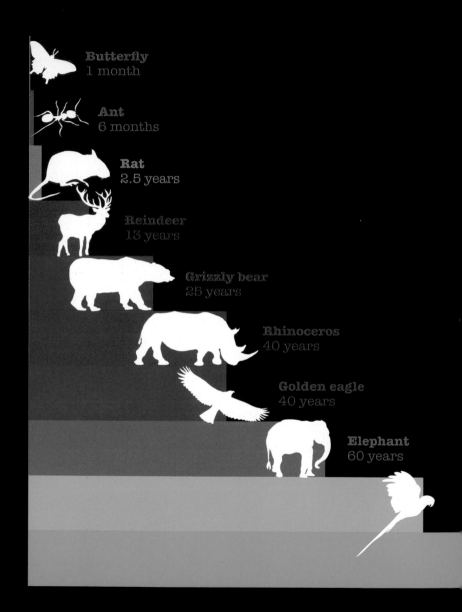

Butterfly
1 month

Ant
6 months

Rat
2.5 years

Reindeer
13 years

Grizzly bear
25 years

Rhinoceros
40 years

Golden eagle
40 years

Elephant
60 years

Average life expectancy

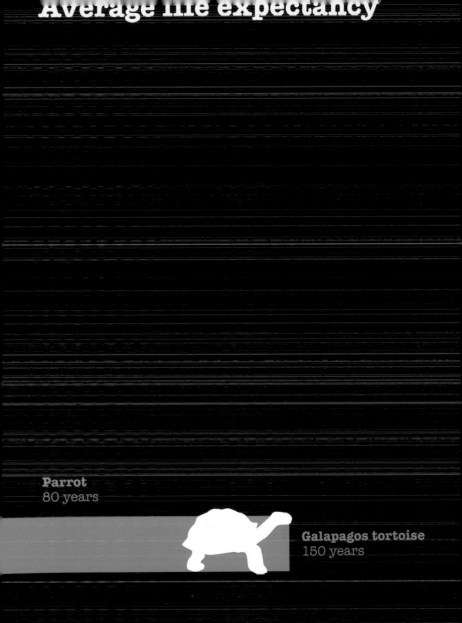

Parrot
80 years

Galapagos tortoise
150 years

Towel folding—chicken

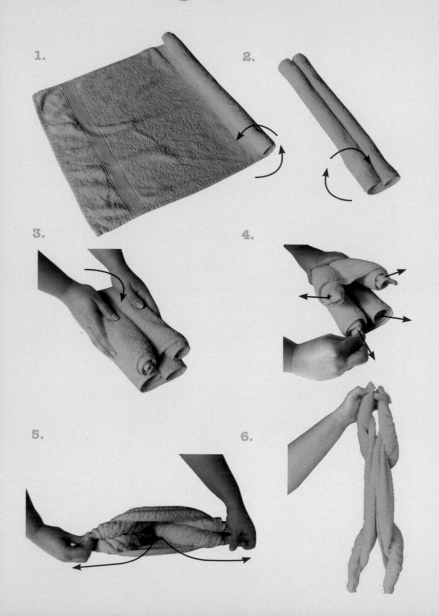

1.

2.

3.

4.

5.

6.

Towel folding—swan

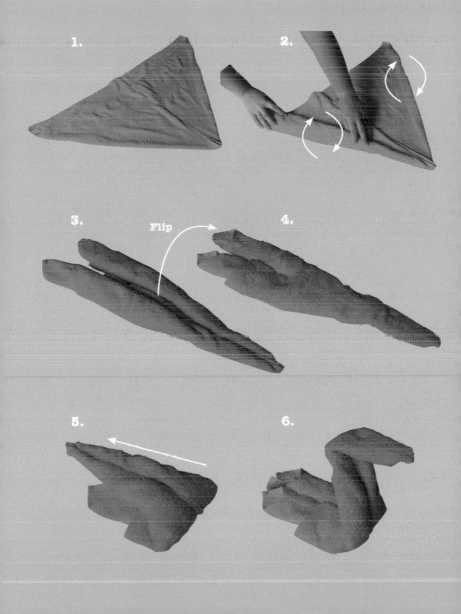

1.

2.

3.

Flip

4.

5.

6.

Origami game

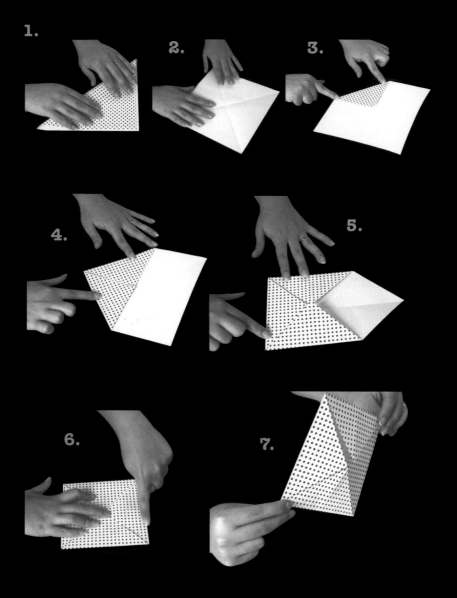

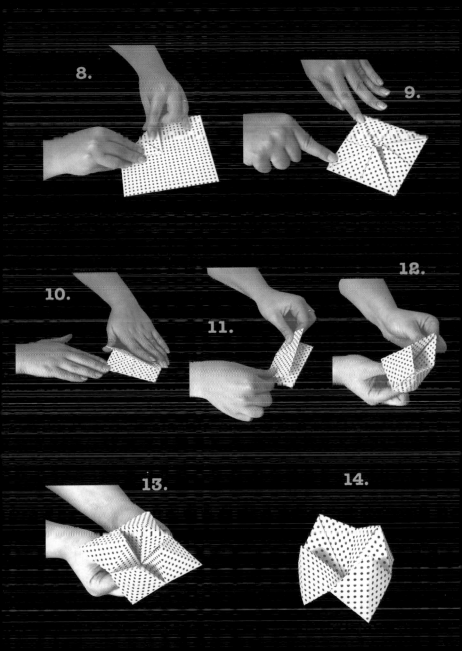

Graphology

Loner
Reserved
Self-centred
Logical

the study of
handwriting
where the slant
of the letters are
considered
an expression
of the writer's
character and
personality

Affectionate
Ambivert
Sharing
Expressive

Needy
Extrovert
Emotional
Impulsive

Palmistry

1 Line of Fate

- Deep line: controlled by fate
- Breaks, changes of direction: influenced by external forces
- Begins at Line of Life: self-made individual
- Joins with Line of Life in the middle: interests must be surrendered to others
- Starts at base of thumb and crosses Line of Life: support offered by family and friends

2 Line of Heart

- Begins below index finger: content love life
- Begins below middle finger: selfish in terms of love
- Begins at middle: easily falls in love
- Short and straight: unromantic
- Touches Line of Life: easily heart-broken
- Curvy and long: expressive with emotions
- Wavy: many relationships and lovers
- Broken line: emotional trauma

3 Line of Head

- Short line: into sports
- Curved, sloping line: creative
- Separated from life line: adventurous, enthusiasm for life
- Wavy line: short attention span
- Deep, long line: clear and focused thinker
- Straight line: realistic thinker
- Cross in Line of Head: emotional crisis
- Broken line of Head: inconsistencies in thought
- Multiple crosses through head line: big decisions

4 Line of Life

- Runs close to thumb: often tired
- Curvy: plenty of energy
- Long and deep: vitality
- Short and shallow: manipulated by others
- Semicircular: strength and enthusiasm
- Straight and close to the edge of the palm: cautious when it comes to relationships
- Multiple life lines: extra vitality
- Break: struggles or losses

5 Line of Sun

- Success, fortune, talent and ability

6 Line of Mercury

- Indicates health issues, business acumen and skills in communication

7 Line of Marriage

- Forked towards the back of the hand: long engagement
- Lines that meet the Line of Marriage: number of children will be born into the marriage

8 Girdle of Venus

- Nervousness and emotional sensitivity

Yoga

Pranayama
Breathing

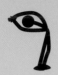

Ardha Chandrasana
Half Moon Pose

Utkatasana
Awkward Pose

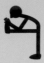

Dandayamana Janushirasana
Standing Head to Knee

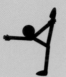

Dandayamana Dhanurasana
Standing Bow Pulling Pose

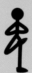

Tuladandasana
Balancing Stick Pose

Dandayamana Bibhaktapada Paschimotthanasa
Standing Separate Leg Stretching Pose

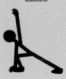

Trikonasana
Triangle Pose

Tadasana
Tree Pose

Savasana
Corpse Pose

Pavana Muktasana
Wind Removing Pose

Sit-up

Bhujangasana
Cobra Pose

Salabhasana
Locust Pose

Poorna Salabhasana
Full Locust Pose

Dhanurasana
Bow Pose

Supta Vajrasna
Fixed Firm Pose

Ardha Kurmasana
Half-Tortoise Pose

Ustrasana
Camel Pose

Sasangasana
Rabbit Pose

Pilates

Chest Lift
Muscles:
upper abs

The Hundred
Muscles:
abdominals and
breathing

The Roll Up
Muscles:
abdominals

One Leg Circle
Muscles:
thighs and hips

Side Kick
Muscles:
abdominals and
inner thigh

Open Leg Balance
Muscles:
abdominals and
hamstring

Roll Up Ball
Muscles:
abdominals

Mermaid
Muscles:
side stretch

Wall Roll Down
Muscles:
abdominals and
inner thigh

Saw
**Muscles: hamstring
and inner thigh**

Front Support
**Muscles: back,
shoulders and arms**

Pelvic Curl
Muscles:
abdominal and core

Swan Prep
Muscles:
abdominals
and back

Oblique Lifts
Muscles:
abdominals
and back

Dermatomes

Dermatomes are useful in neurology for finding the site of damage to the spinal cord by using the relevant parts of the body as indicators.

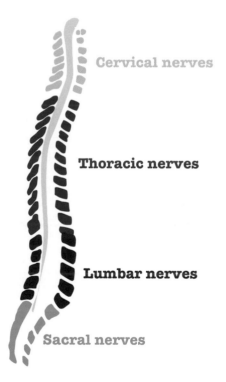

Cervical nerves

Thoracic nerves

Lumbar nerves

Sacral nerves

Reflex points

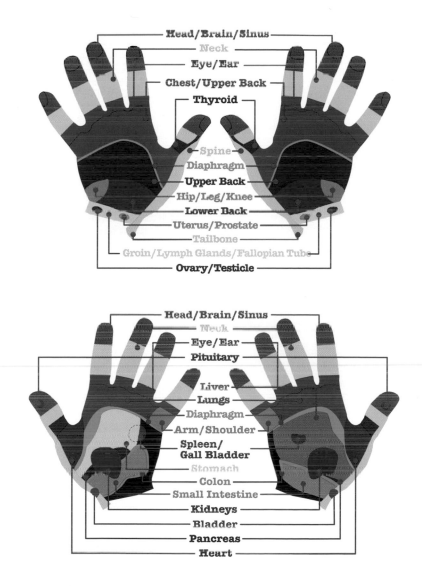

Head/Brain/Sinus
Neck
Eye/Ear
Chest/Upper Back
Thyroid
Spine
Diaphragm
Upper Back
Hip/Leg/Knee
Lower Back
Uterus/Prostate
Tailbone
Groin/Lymph Glands/Fallopian Tube
Ovary/Testicle

Head/Brain/Sinus
Neck
Eye/Ear
Pituitary
Liver
Lungs
Diaphragm
Arm/Shoulder
Spleen/
Gall Bladder
Stomach
Colon
Small Intestine
Kidneys
Bladder
Pancreas
Heart

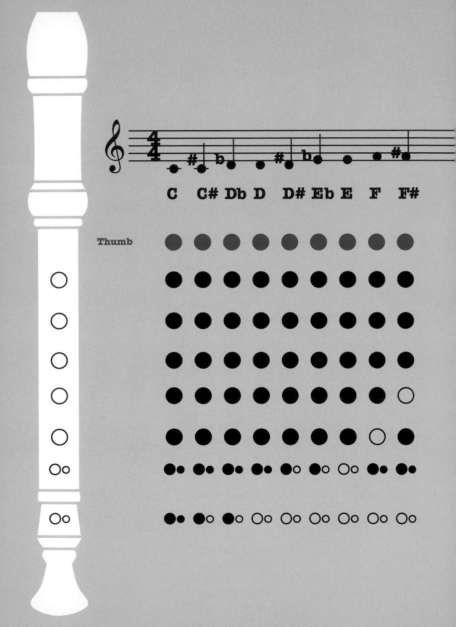

Play the recorder

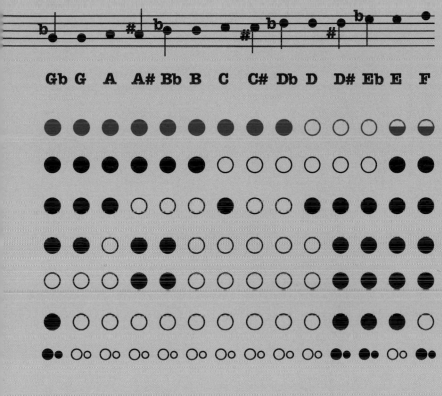

Upright piano

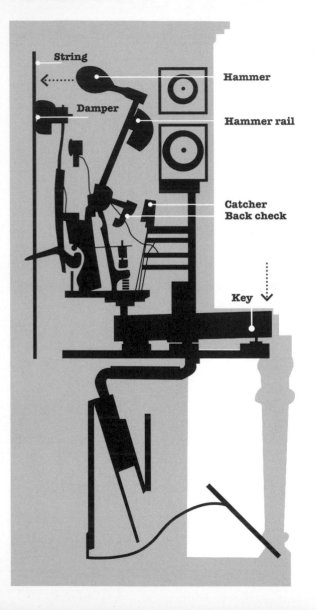

String

Hammer

Damper

Hammer rail

Catcher
Back check

Key

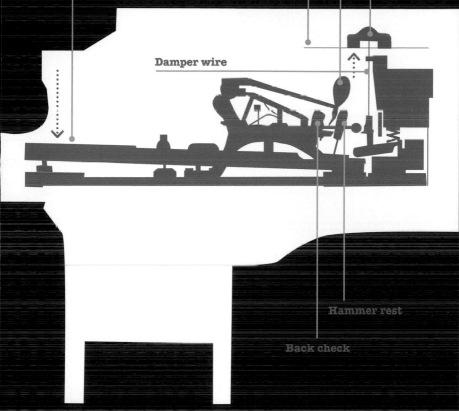

Damper wire

Hammer rest

Back check

Orchestra layout

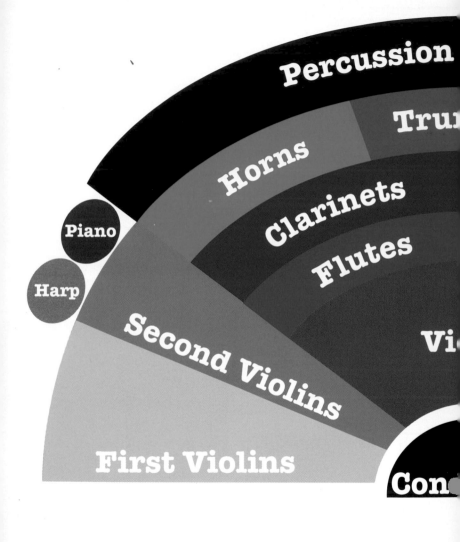

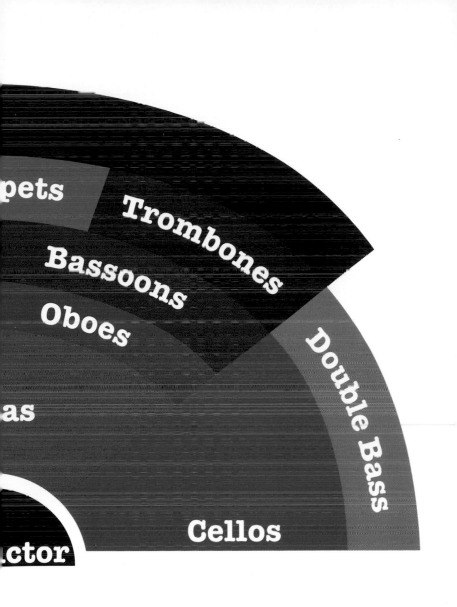

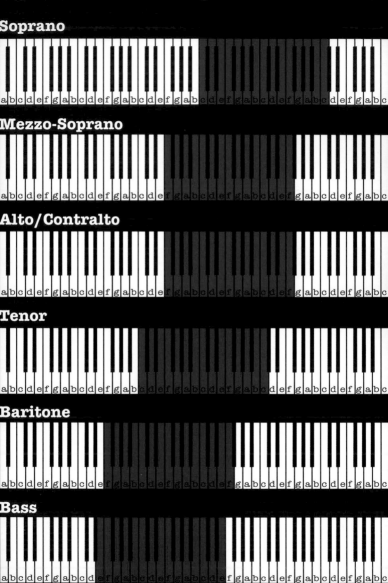

Conducting patterns

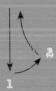

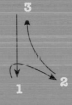

Two beat

Three beat

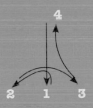

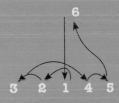

Four beat

Six beat

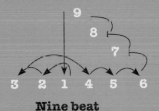

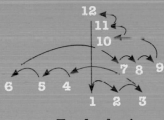

Nine beat

Twelve beat

Juggling

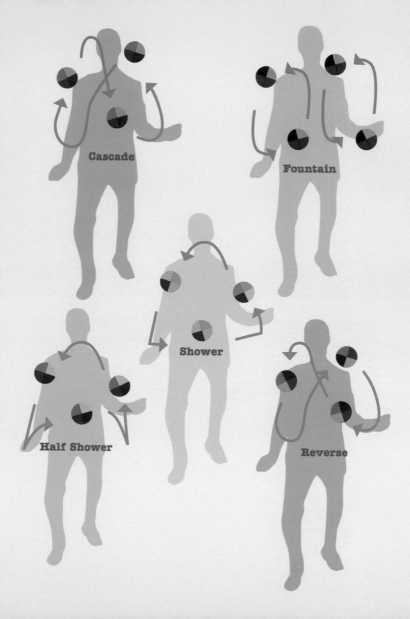

Cascade

Fountain

Shower

Half Shower

Reverse

Clown types

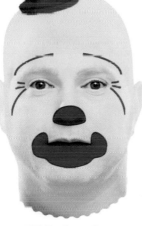

White face clown
Serious, all knowing

Auguste clown
Least intelligent, anarchist

Character clown
Loner, silent, scapegoat

Yo-yoing

Power throw

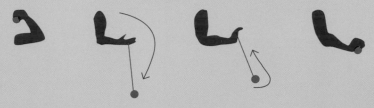

Rock the baby

Loop the loop

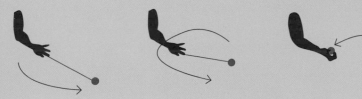

Flying saucer

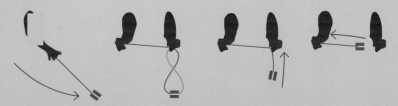

Geographic Monopoly board

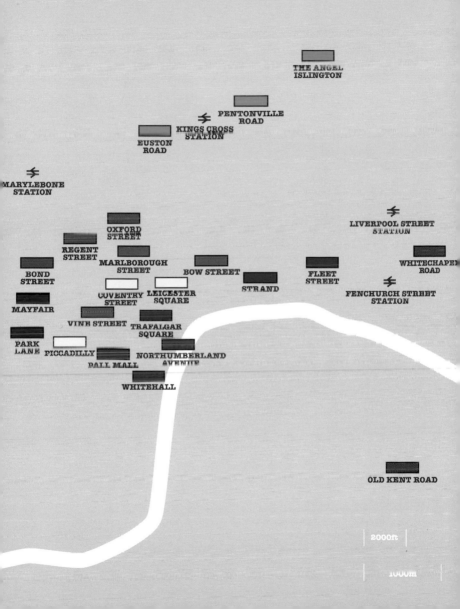

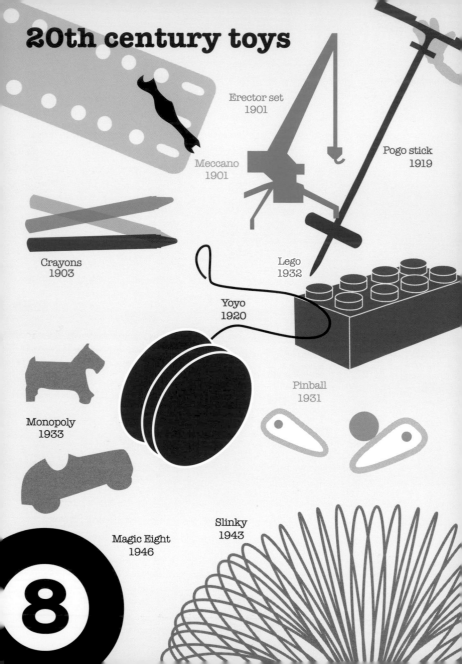

20th century toys

Erector set
1901

Meccano
1901

Pogo stick
1919

Crayons
1903

Lego
1932

Yoyo
1920

Monopoly
1933

Pinball
1931

Magic Eight
1946

Slinky
1943

8

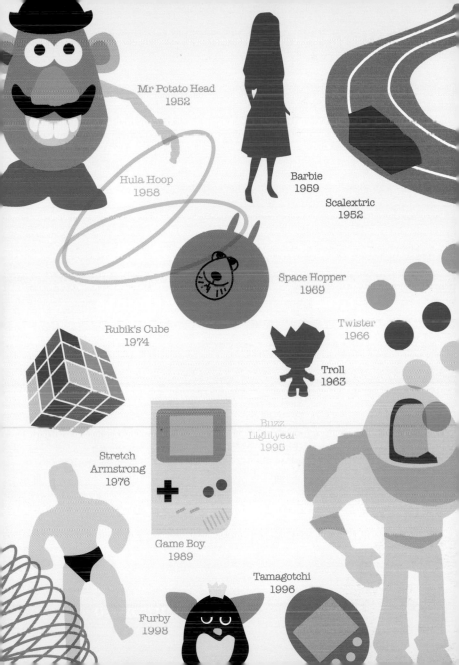

Mr Potato Head
1952

Hula Hoop
1958

Barbie
1959

Scalextric
1952

Space Hopper
1969

Twister
1966

Rubik's Cube
1974

Troll
1963

Buzz
Lightyear
1995

Stretch
Armstrong
1976

Game Boy
1989

Tamagotchi
1996

Furby
1998

Camouflage

UK
Desert

Poland
Pine

Germany
Splinter

Kopassus
Blood Vine

Malaysia
Khidmat Negara

Yugoslavia
Branches

Uruguay
Mitchell Pattern

USA
Urban

Turkey
Compressed Leaf

Benin
Airborne

Australia
AUSCAM desert

Sweden
Feltantrekk

Vietnam
Leaf Pattern

Libya
Africa Corps

UK
Woodland

USSR
Computer Pattern

USA
Woodland

Sweden
Fältjacka

Germany
Flower Pattern

Philippines
PSG

Malaysia
Bomba

Uganda

Spain

Portugal

Battle of Trafalgar
21 October 1805

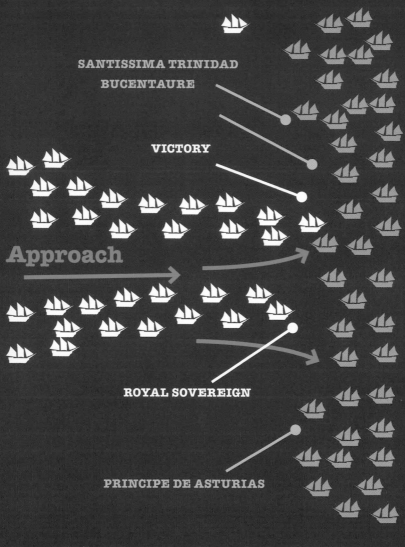

SANTISSIMA TRINIDAD

BUCENTAURE

VICTORY

Approach

ROYAL SOVEREIGN

PRINCIPE DE ASTURIAS

British VS French & Spanish

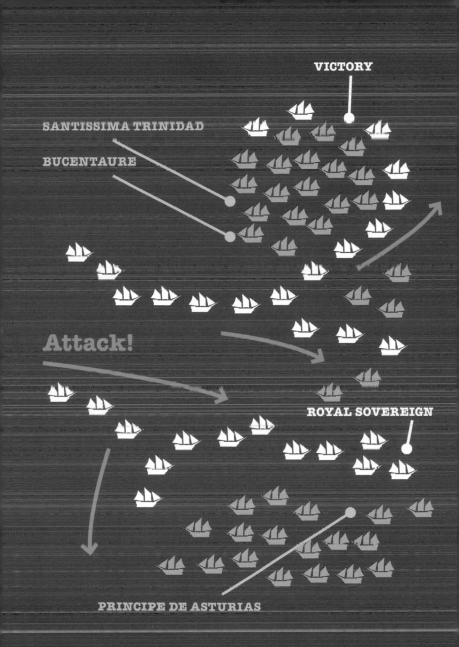

VICTORY

SANTISSIMA TRINIDAD

BUCENTAURE

Attack!

ROYAL SOVEREIGN

PRINCIPE DE ASTURIAS

Pirate Flags

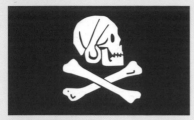

Henry Every

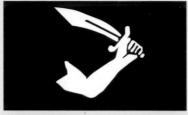

Thomas Tew

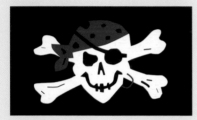

One Eyed Jack

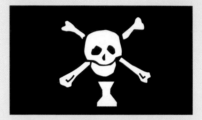

Emmanuel Wynne

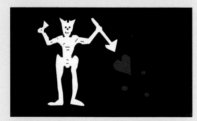

Edward Teach (Blackbeard)

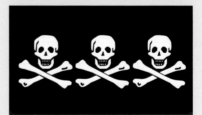

Christopher Condent

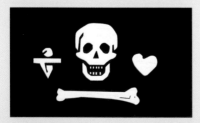

Stede Bonnet

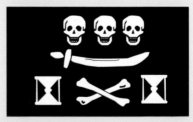

Captain Dulaien

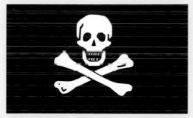

Edward England

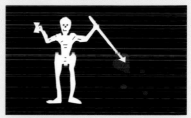

John Quelch

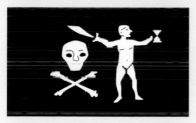

Walter Kennedy

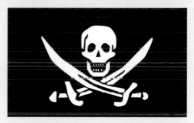

John Rackham (Calico Jack)

Edward Low

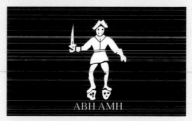

ABH AMH

Bartholomew Roberts

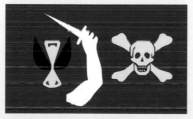

Christopher Moody

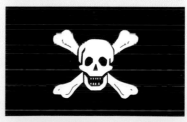

Richard Worley